★ ★ ★

IN
DOG
WE
TRUST

★ ★ ★

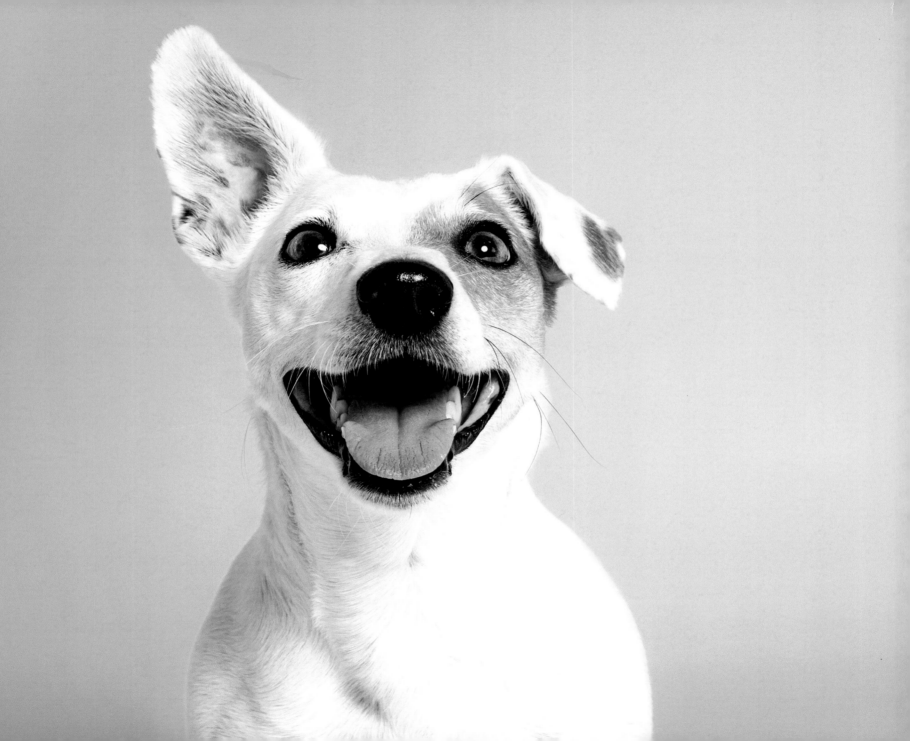

IN DOG WE TRUST

A CELEBRATION OF THOSE

WHO NEVER LET US DOWN

MARY ZAIA

Castle Point Books
New York

www.castlepointbooks.com

The Castle Point Books trademark is owned by Castle Point Publishing, LLC.
Castle Point books are published and distributed by St. Martin's Publishing Group.

ISBN 978-1-250-27555-4 (hardcover)
ISBN 978-1-250-27556-1 (ebook)

Cover design by Melissa Gerber
Interior design by Mary Velgos
Edited by Monica Sweeney

Our books may be purchased in bulk for promotional, educational, or business use.
Please contact your local bookseller or the Macmillan Corporate and Premium Sales Department
at 1-800-221-7945, extension 5442, or by email at MacmillanSpecialMarkets@macmillan.com.

First Edition: 2021

10 9 8 7 6 5 4 3 2

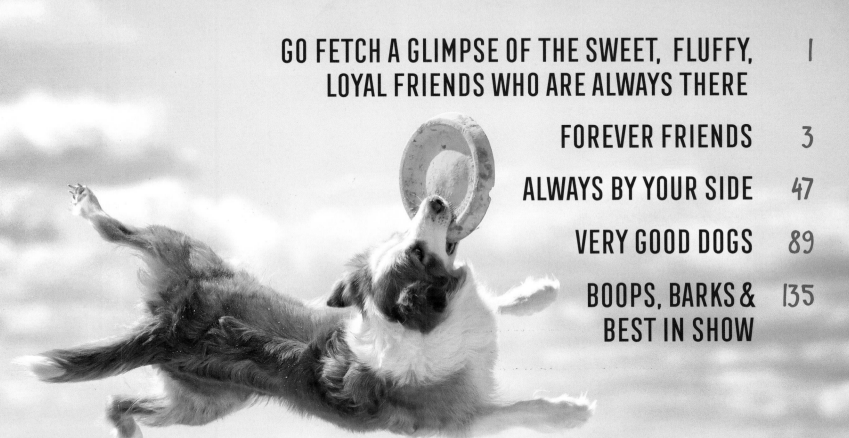

CONTENTS

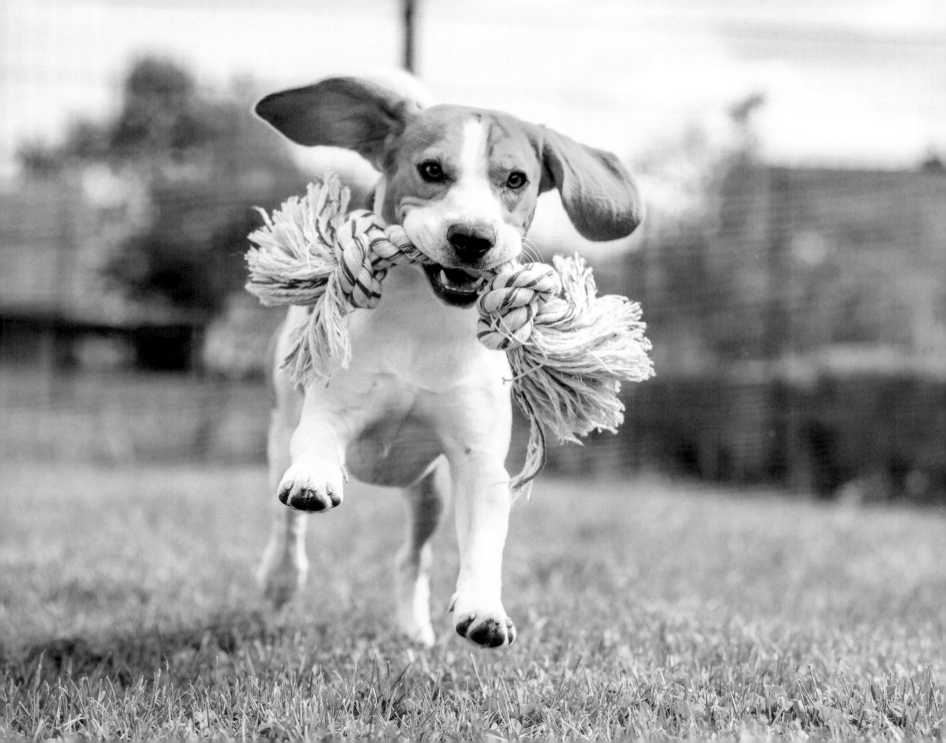

GO FETCH A GLIMPSE
OF THE SWEET, FLUFFY, LOYAL FRIENDS
WHO ARE ALWAYS THERE!

The gift of friendship with a beloved dog is unlike any other. The playful spirit, the unwavering devotion, and the compassion and warmth of dogs are to be cherished. *In Dog We Trust* is a celebration of the joyful hearts of canines everywhere. It's a testament to the bond between dog lovers and their four-legged friends and the pure friendship expressed by wagging tails, boundless enthusiasm, and unconditional love. This photographic tribute to pups of all shapes and sizes comes with musings and uplifting words that remind us just what these friendships bring to our lives. Enjoy the heartwarming depictions of playful pooches that follow and celebrate the optimism, zest for life, and unrelenting energy with every bark, boop, and wag of a tail in *In Dog We Trust*.

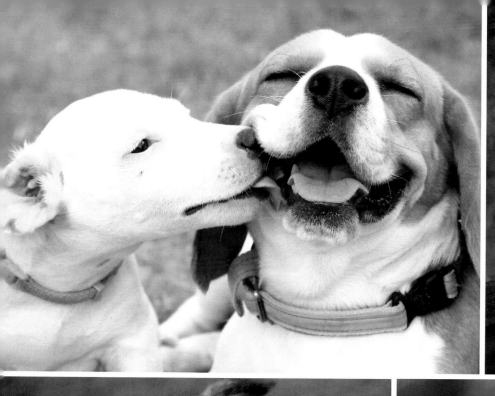
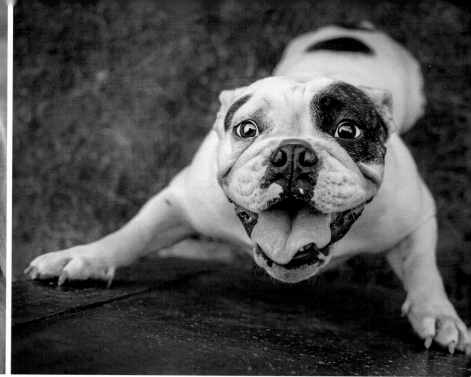
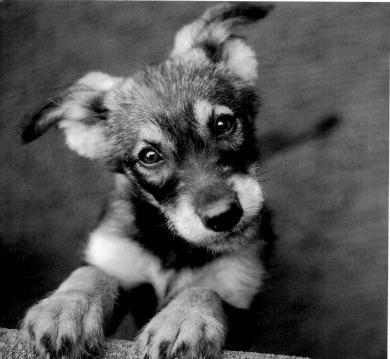
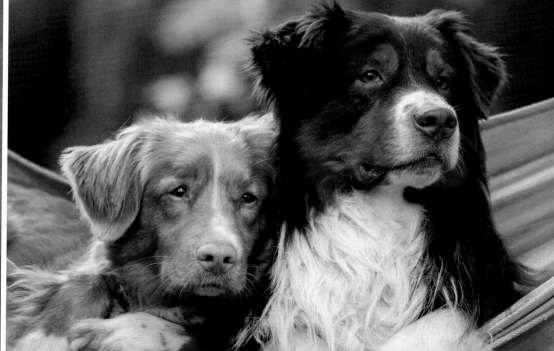

FOREVER
FRIENDS

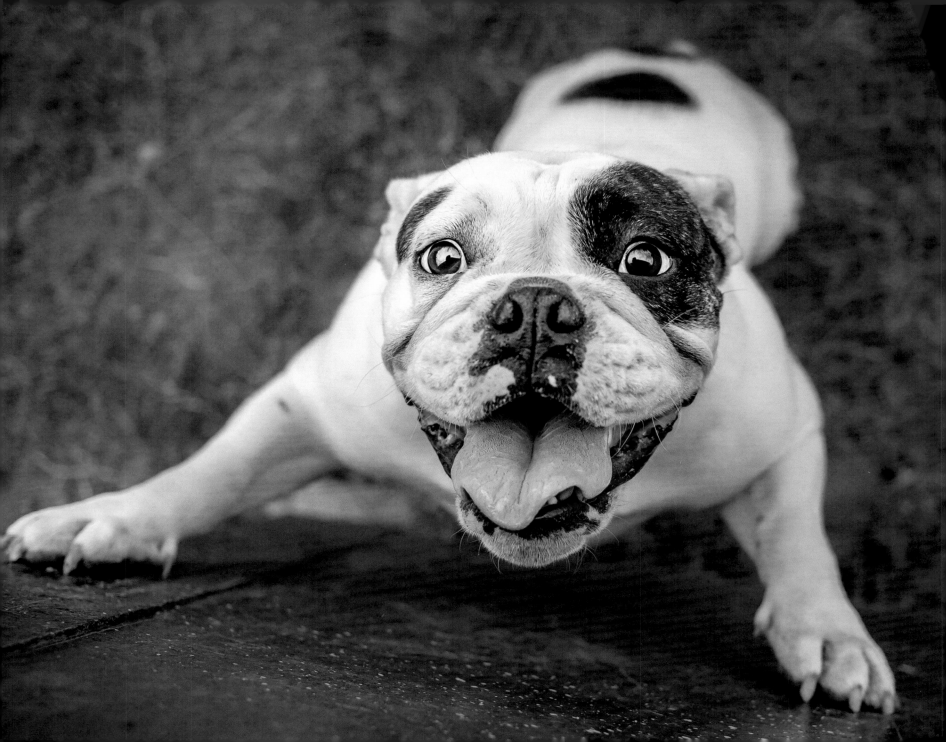

A DOG IS THE ONLY THING ON EARTH THAT LOVES YOU MORE THAN HE LOVES HIMSELF.

JOSH BILLINGS

OUTSIDE OF A DOG,
A BOOK IS MAN'S BEST FRIEND.
INSIDE OF A DOG
IT'S TOO DARK TO READ.

GROUCHO MARX

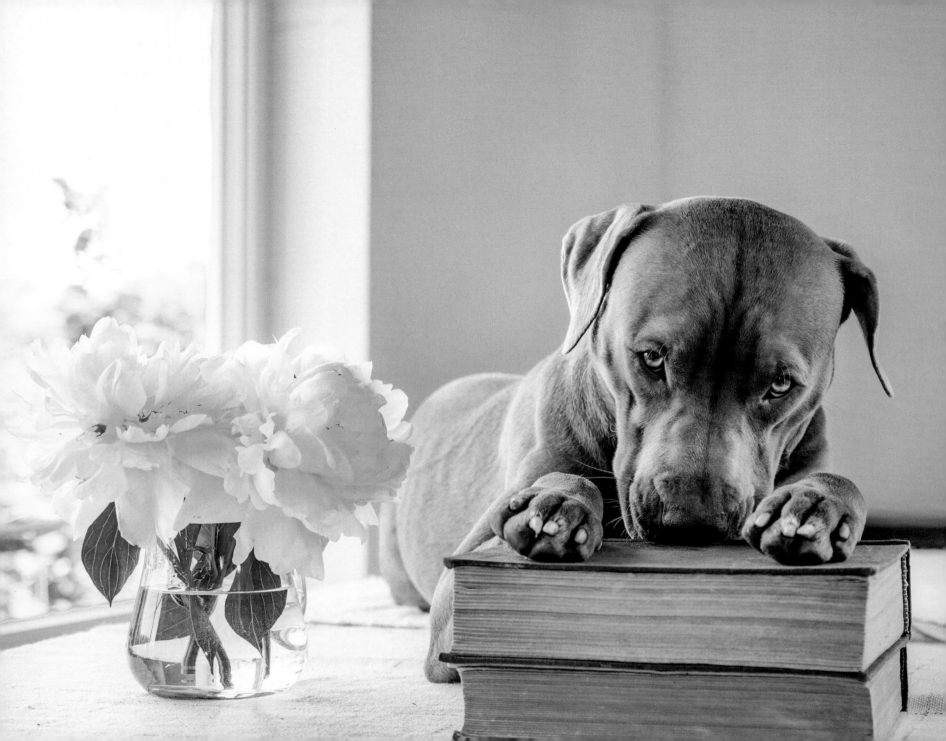

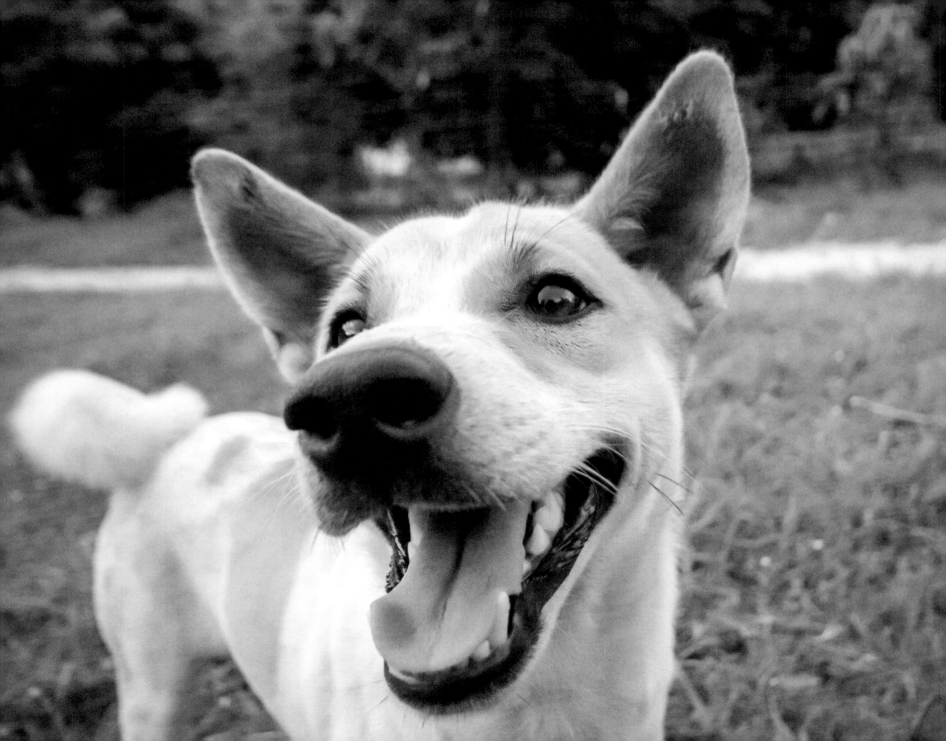

MONEY CAN BUY YOU A FINE DOG, BUT ONLY LOVE CAN MAKE HIM WAG HIS TAIL.

KINKY FRIEDMAN

FALL IN LOVE WITH A DOG, AND
IN MANY WAYS YOU ENTER A NEW ORBIT;
A UNIVERSE THAT FEATURES NOT JUST
NEW COLORS BUT NEW RITUALS,
NEW RULES, A NEW WAY
OF EXPERIENCING ATTACHMENT.

CAROLINE KNAPP

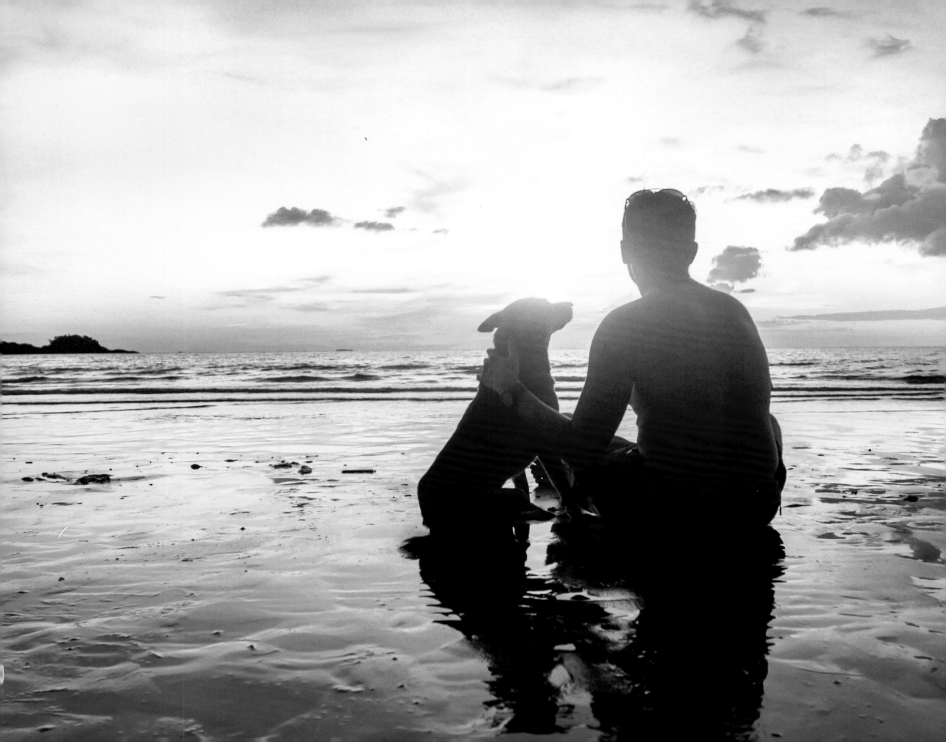

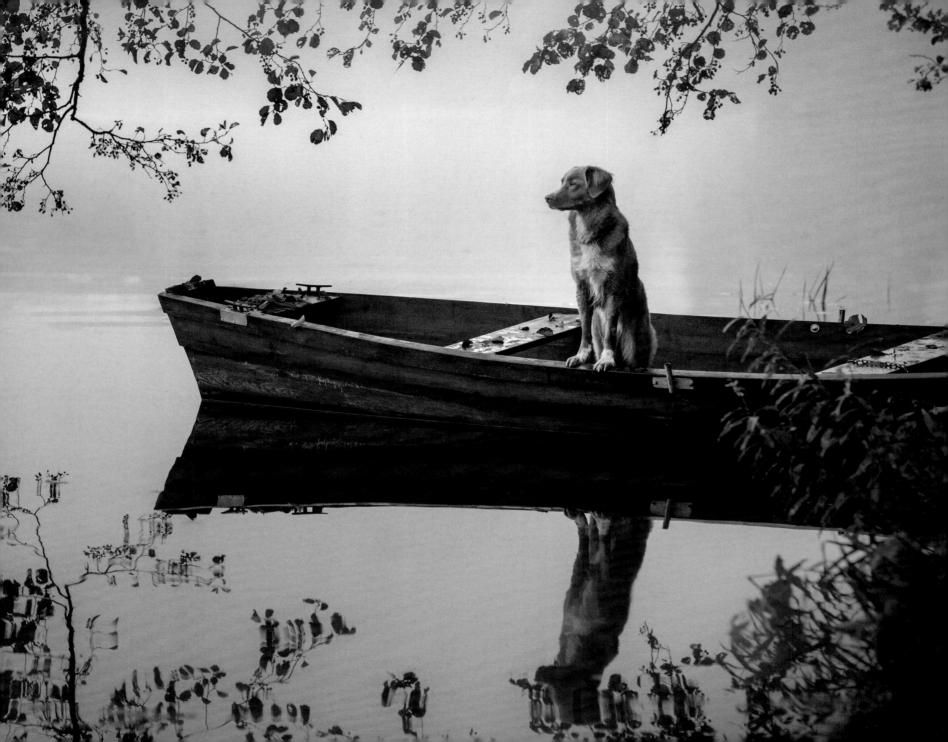

THE BOND WITH A TRUE DOG
IS AS LASTING AS
THE TIES OF THIS EARTH
WILL EVER BE.

MY LITTLE DOG—
A HEARTBEAT AT MY FEET.

EDITH WHARTON

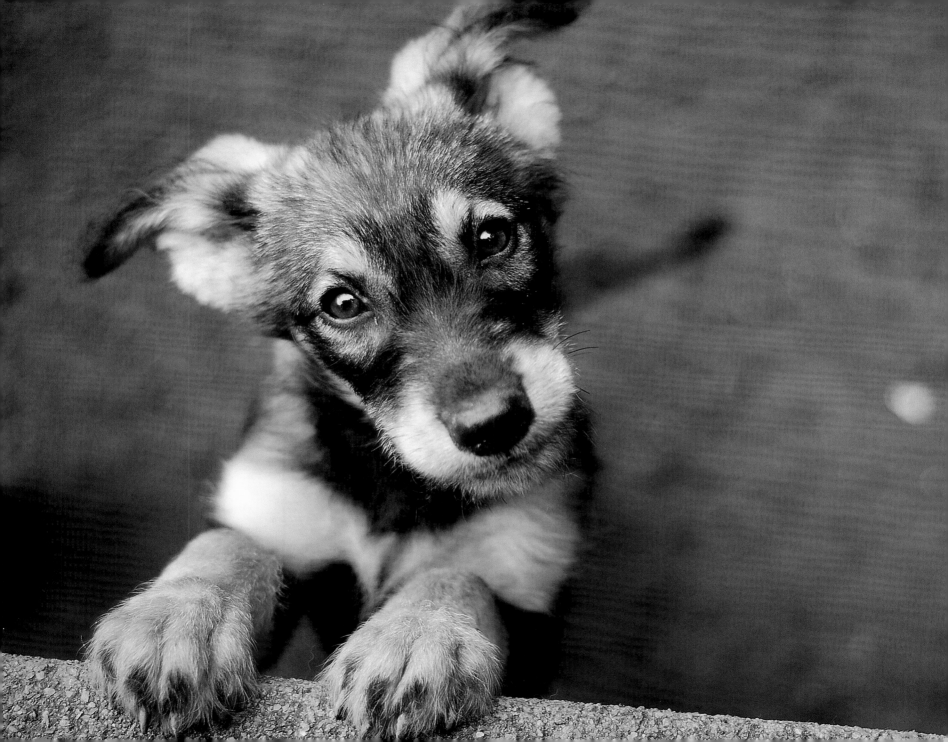

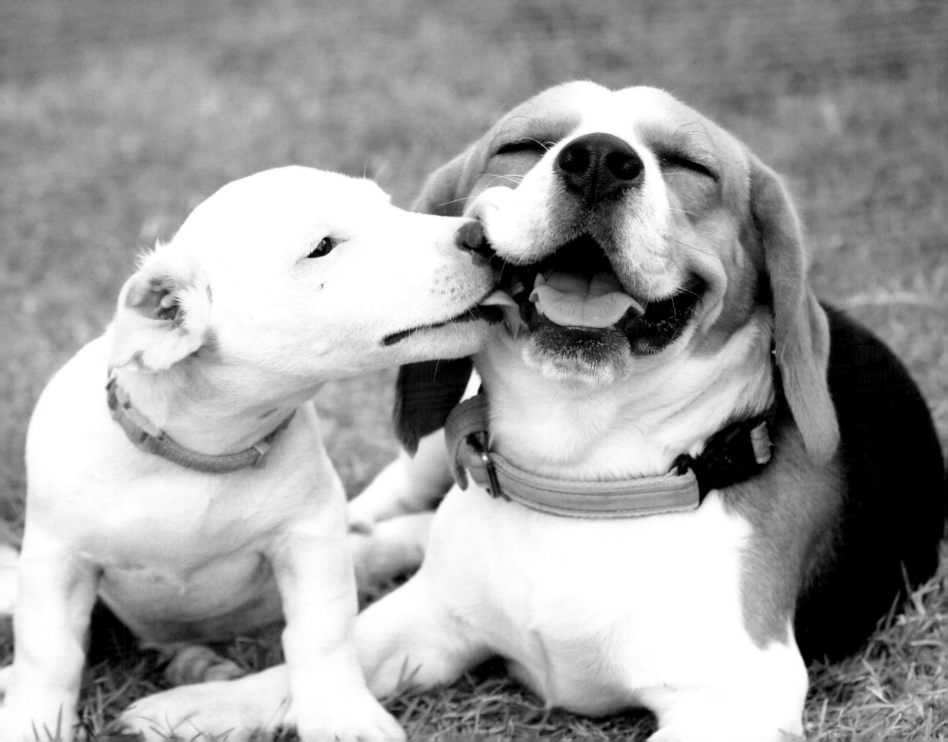

A DOG WILL TEACH YOU UNCONDITIONAL LOVE.

IF YOU CAN HAVE THAT IN YOUR LIFE, THINGS WON'T BE TOO BAD.

ROBERT WAGNER

MY SUNSHINE
DOESN'T COME FROM THE SKIES.
IT COMES FROM THE LOVE
THAT'S IN MY DOG'S EYES.

UNKNOWN

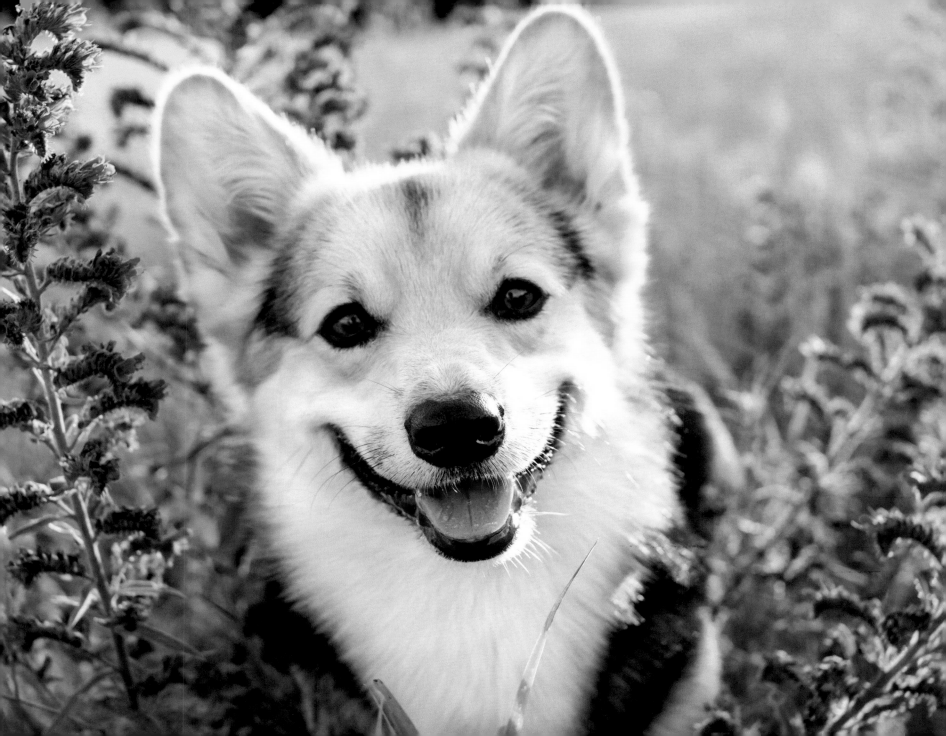

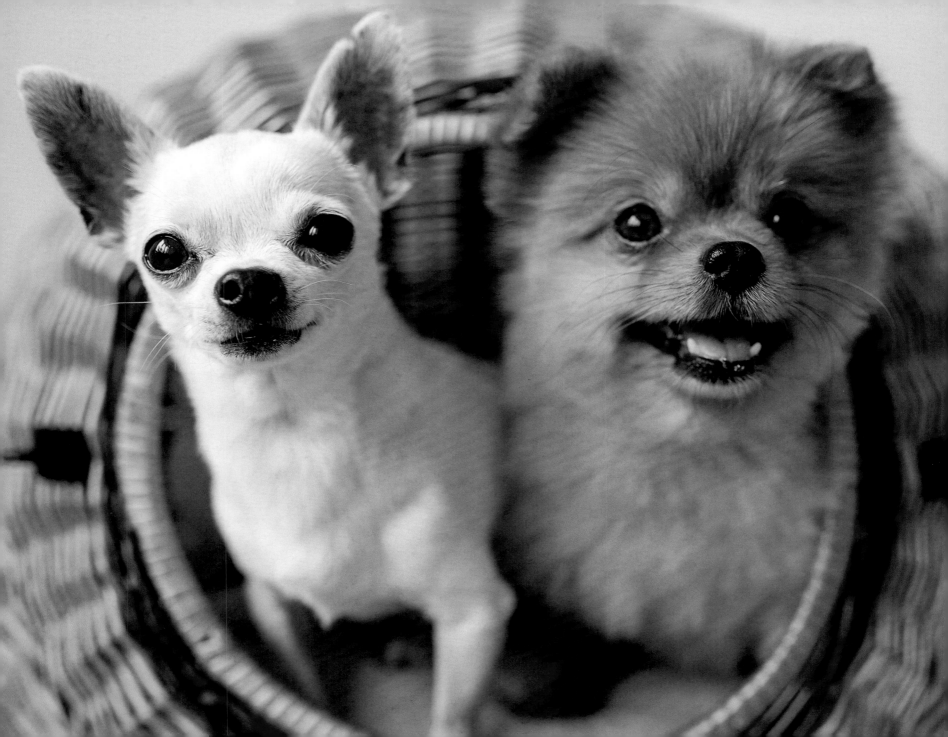

NO ANIMAL I KNOW OF CAN CONSISTENTLY BE MORE OF A FRIEND AND COMPANION THAN A DOG.

STANLEY LEINWOLL

THORNS MAY HURT YOU,
MEN DESERT YOU,
SUNLIGHT TURN TO FOG;
BUT YOU'RE NEVER FRIENDLESS EVER,
IF YOU HAVE A DOG.

DOUGLAS MALLOCH

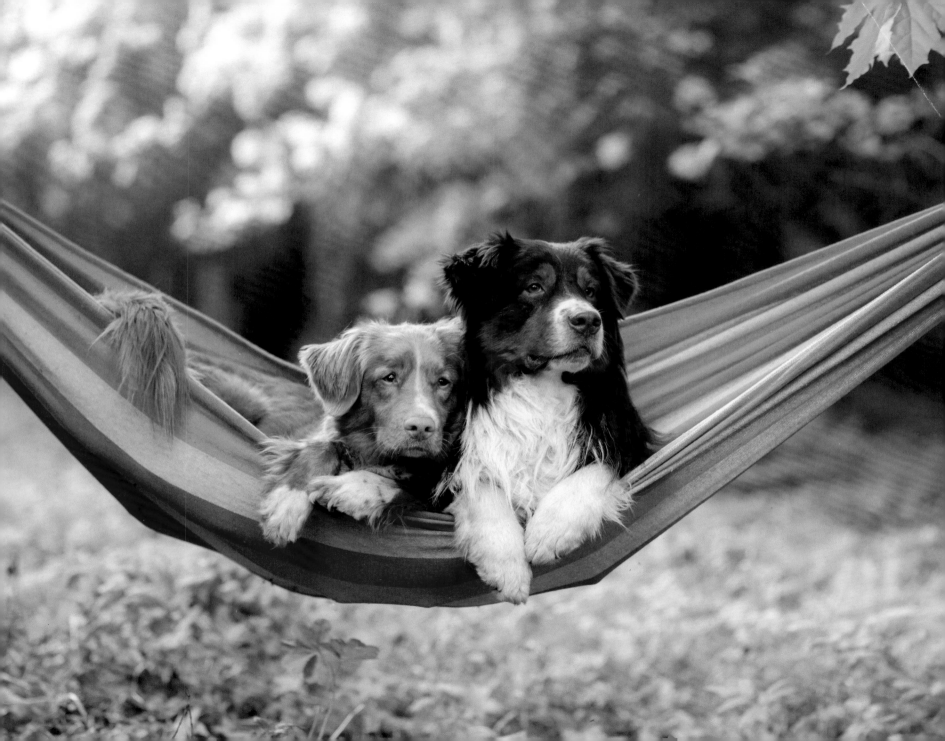

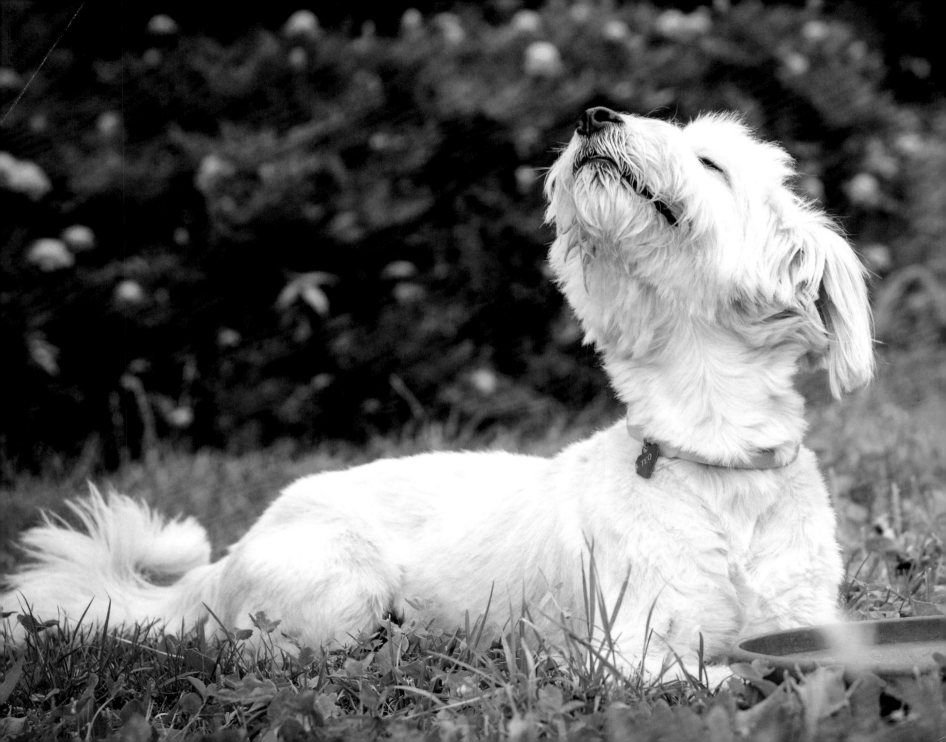

PERHAPS ONE CENTRAL REASON FOR LOVING DOGS IS THAT THEY TAKE US AWAY FROM THIS OBSESSION WITH OURSELVES THE DOG OPENS A WINDOW INTO THE DELIGHT OF THE MOMENT.

JEFFREY MOUSSAIEFF MASSON

BLESSED IS THE PERSON
WHO HAS EARNED THE LOVE OF AN OLD DOG.

SIDNEY JEANNE SEWARD

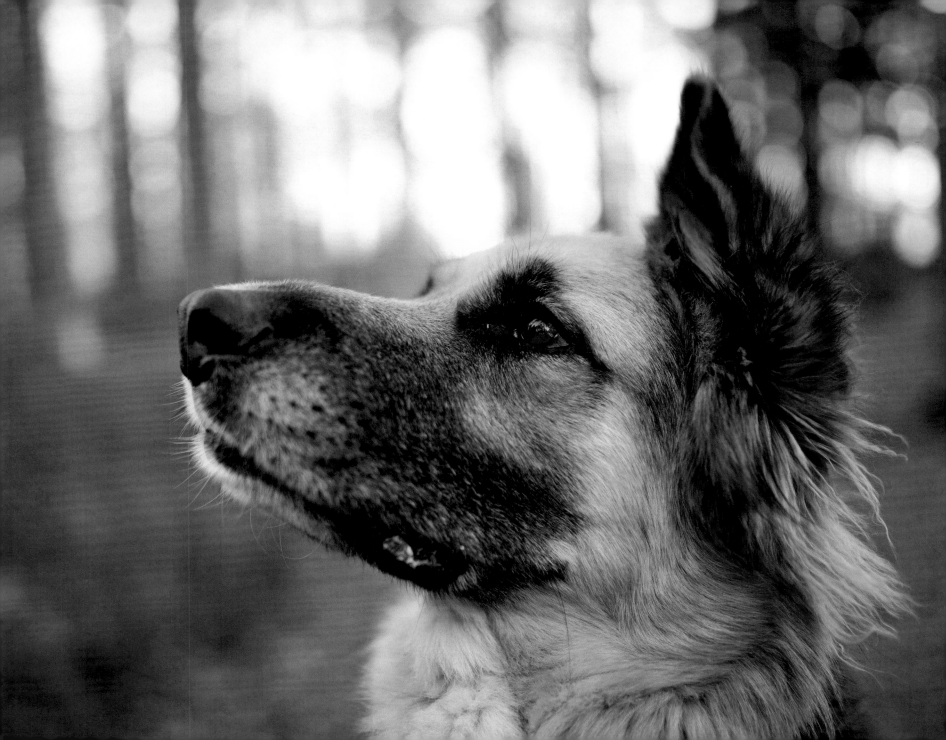

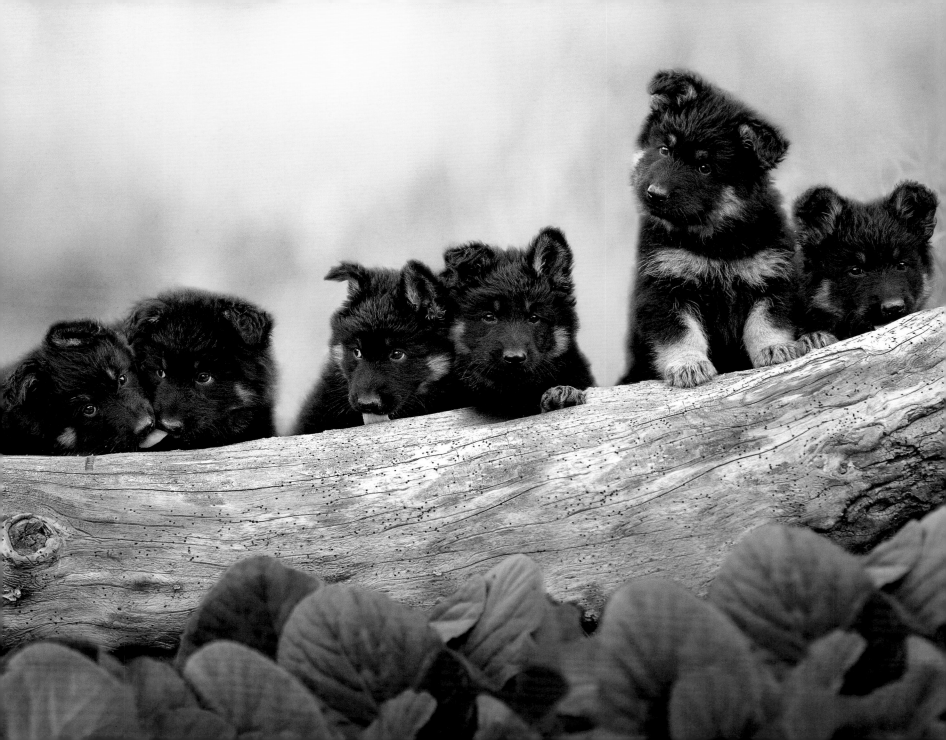

TO HIS DOG, EVERY MAN IS NAPOLEON; HENCE THE CONSTANT POPULARITY OF DOGS.

ALDOUS HUXLEY

YOU CAN USUALLY TELL THAT A MAN IS GOOD IF HE HAS A DOG WHO LOVES HIM.

W. BRUCE CAMERON

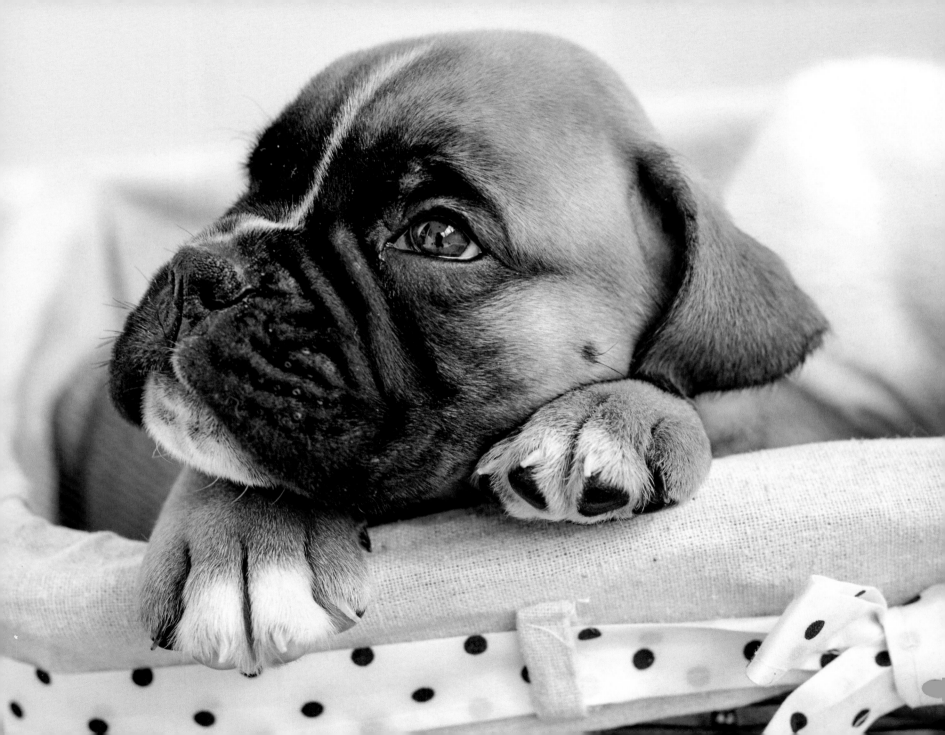

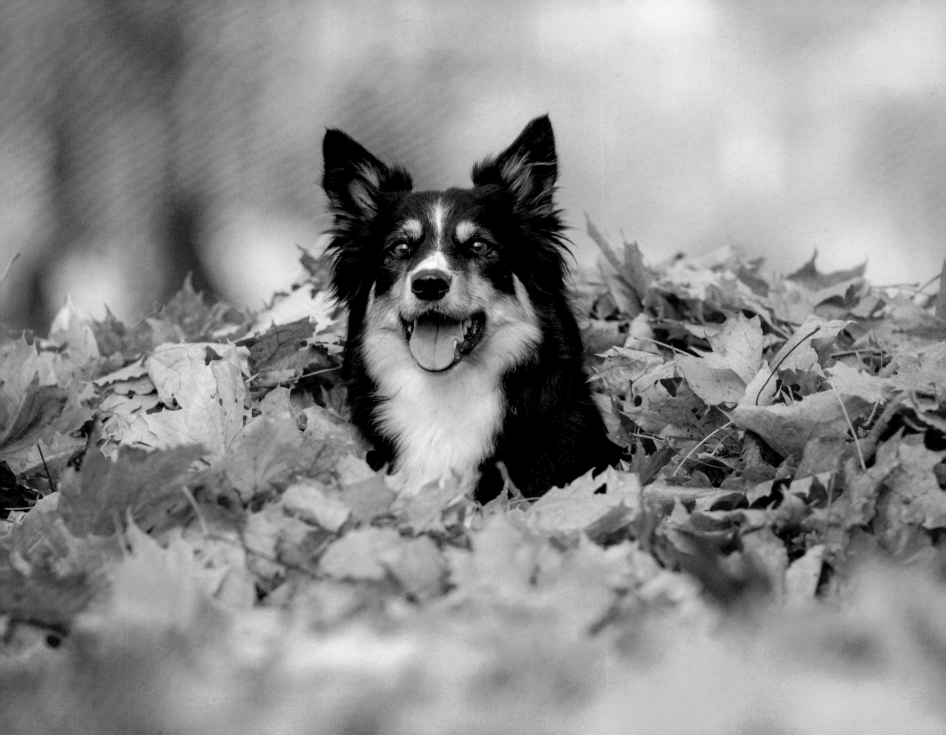

THE ONE ABSOLUTELY UNSELFISH FRIEND THAT MAN CAN HAVE IN THIS SELFISH WORLD, **THE ONE THAT NEVER DESERTS HIM, THE ONE THAT NEVER PROVES UNGRATEFUL OR TREACHEROUS,** IS HIS DOG.

GEORGE GRAHAM

THE FACE
OF A GOLDEN RETRIEVER
FEELS LIKE HOME.

DAVID ROSENFELT

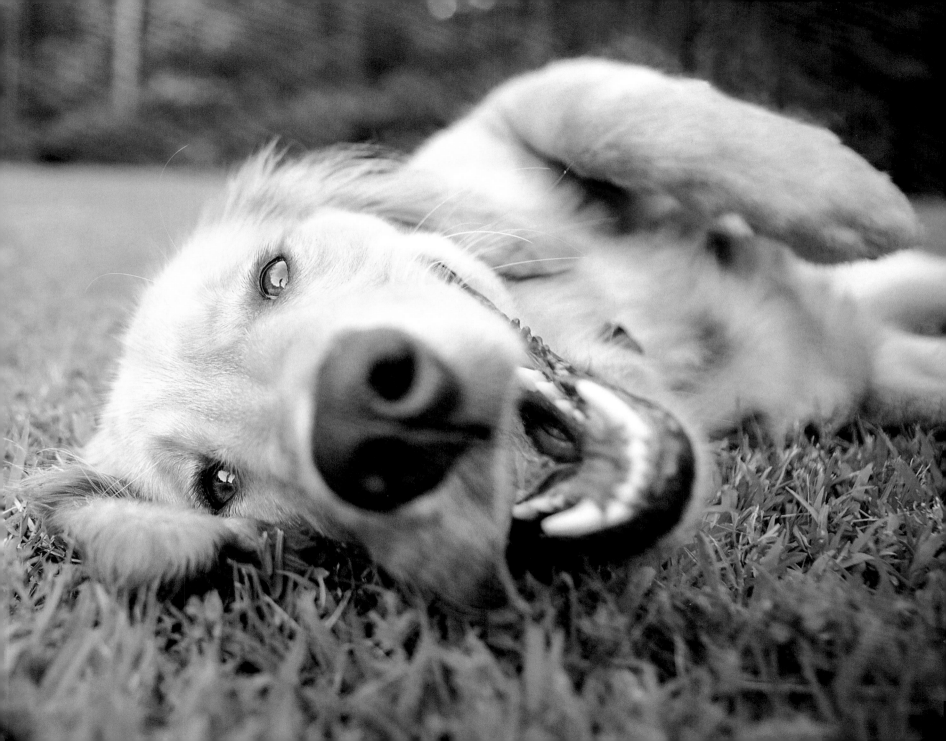

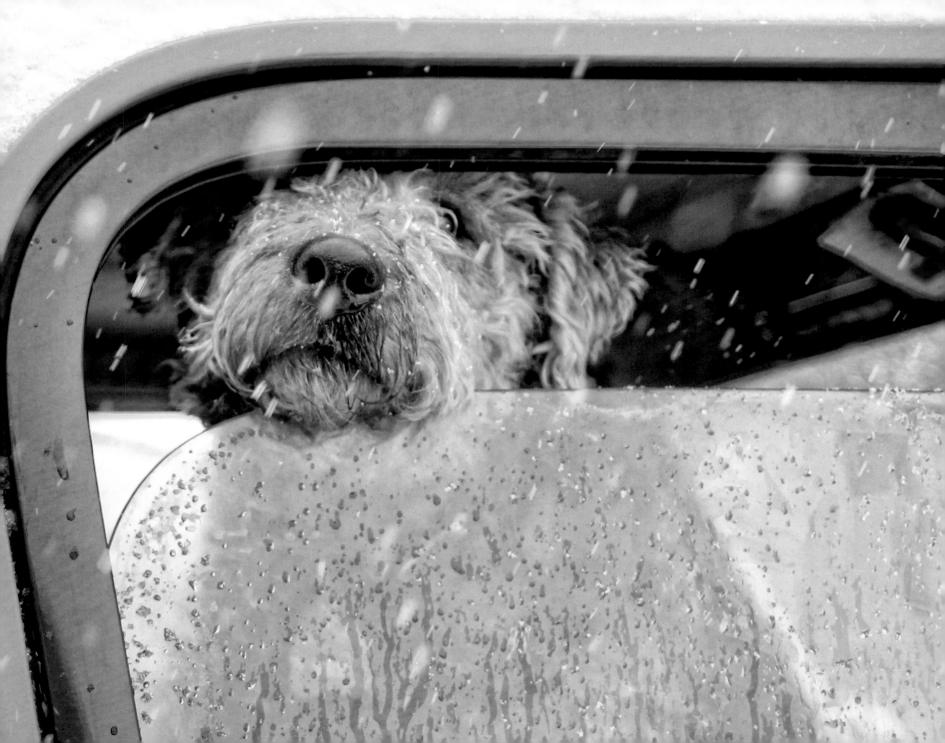

WHAT DOGS WANT MOST IN LIFE
IS FOR NO ONE TO GO AWAY.

JOSÉ SARAMAGO

NO ONE APPRECIATES THE VERY SPECIAL GENIUS OF YOUR CONVERSATION AS THE DOG DOES.

CHRISTOPHER MORLEY

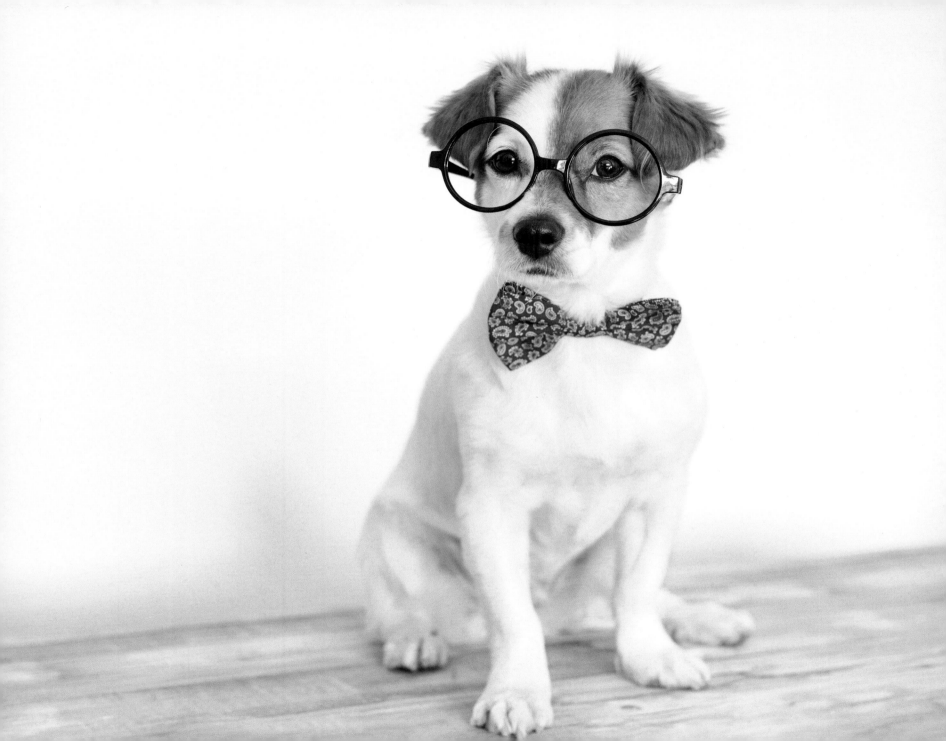

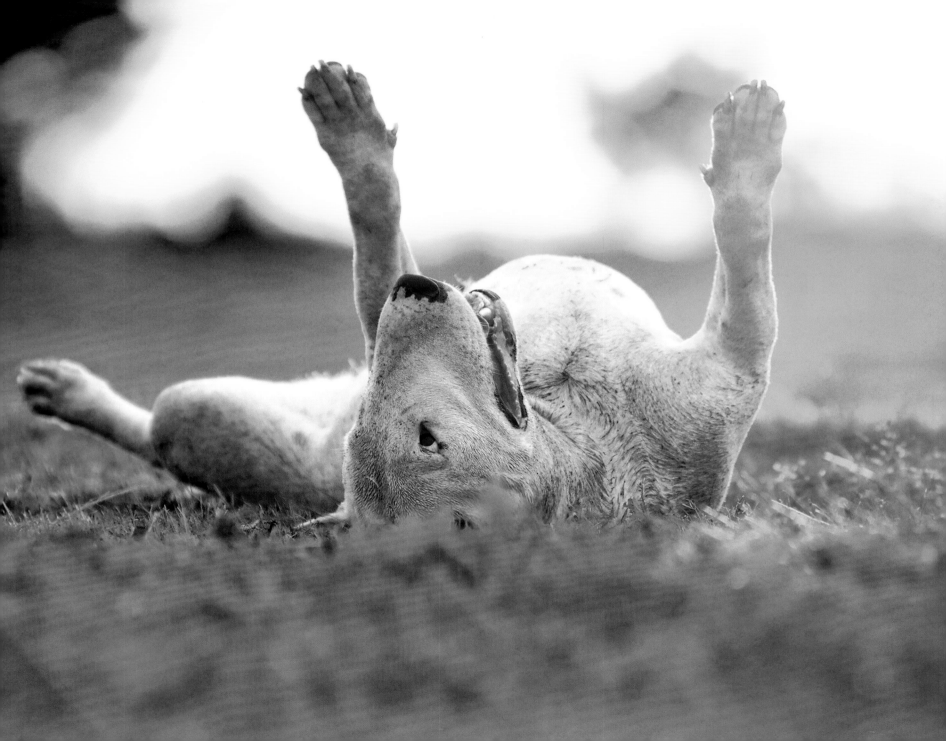

A DOG TEACHES A BOY FIDELITY, PERSEVERANCE, AND TO TURN AROUND THREE TIMES BEFORE LYING DOWN.

ROBERT BENCHLEY

ACQUIRING A DOG
MAY BE THE ONLY TIME
A PERSON GETS TO
CHOOSE A RELATIVE.

MORDECAI SIEGAL

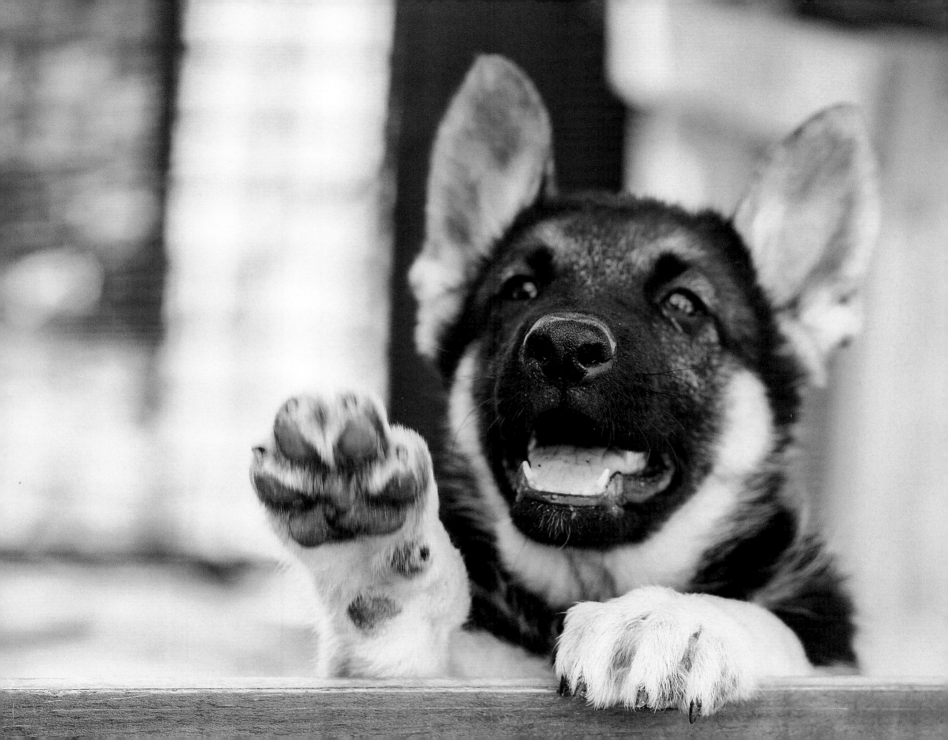

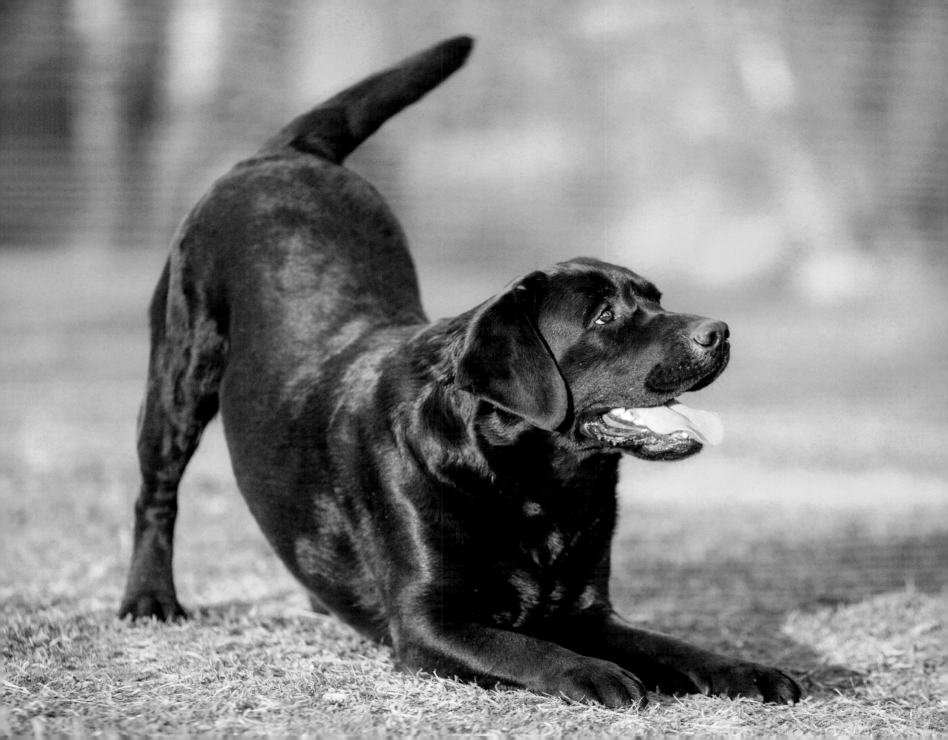

THE FRIENDSHIP
OF A DOG IS PRECIOUS.

IT BECOMES EVEN MORE SO WHEN ONE
IS SO FAR REMOVED FROM HOME.

DWIGHT D. EISENHOWER

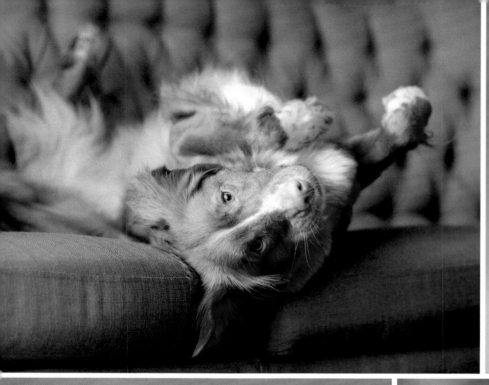
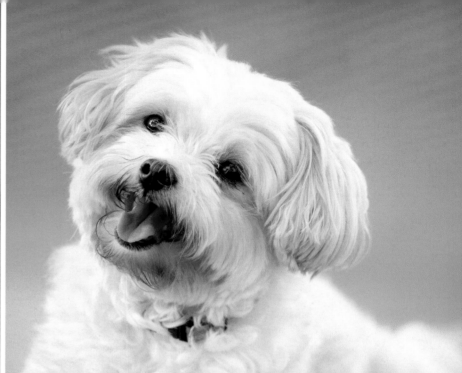
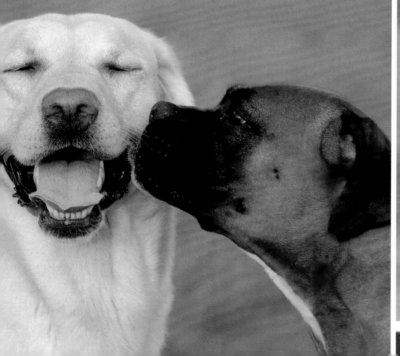
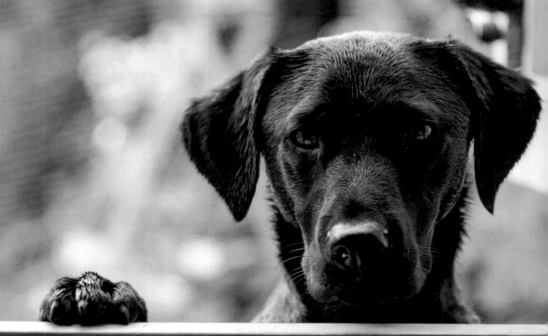

ALWAYS
BY YOUR SIDE

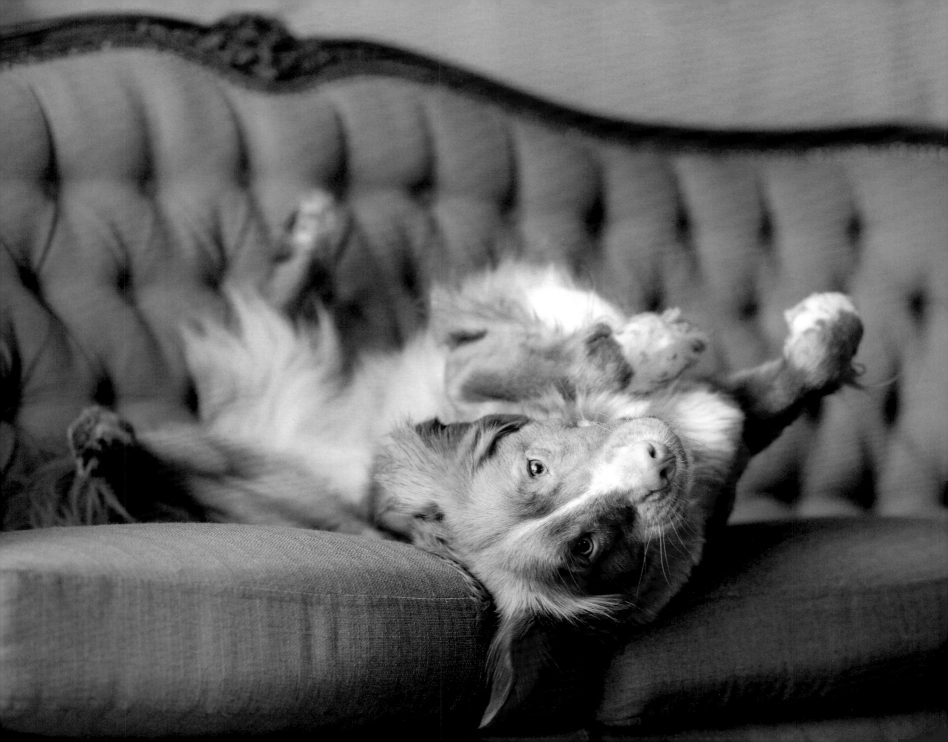

IF YOU PICK UP A STARVING DOG
AND MAKE HIM PROSPEROUS
HE WILL NOT BITE YOU.
THIS IS THE PRINCIPAL DIFFERENCE
BETWEEN A DOG AND MAN.

MARK TWAIN

THERE IS NO FAITH
WHICH HAS NEVER YET BEEN BROKEN,
EXCEPT THAT OF
A TRULY FAITHFUL DOG.

KONRAD LORENZ

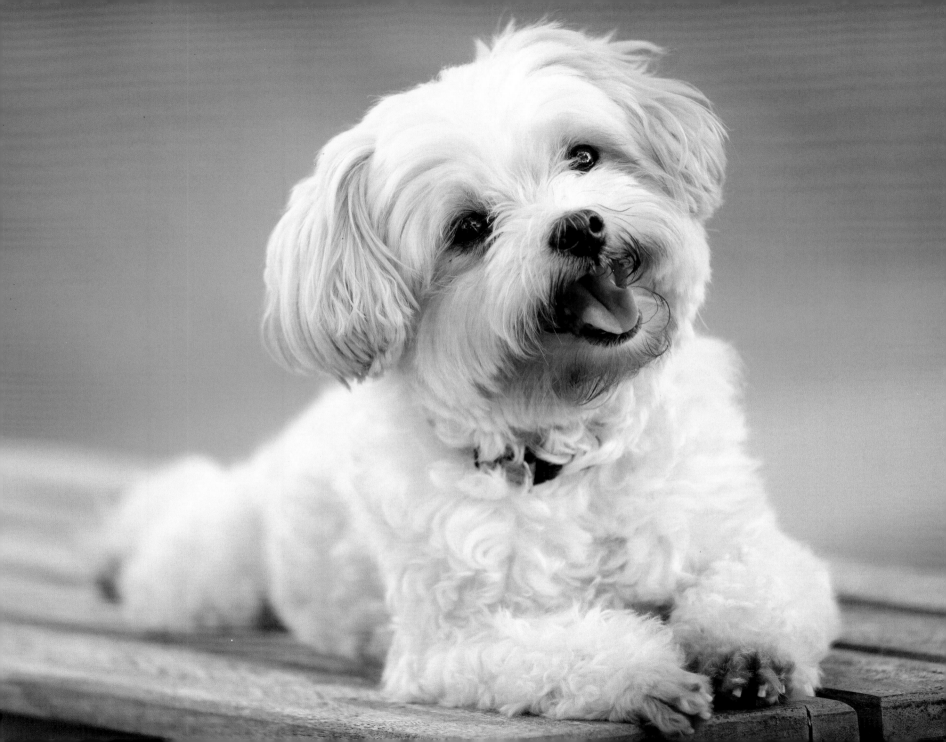

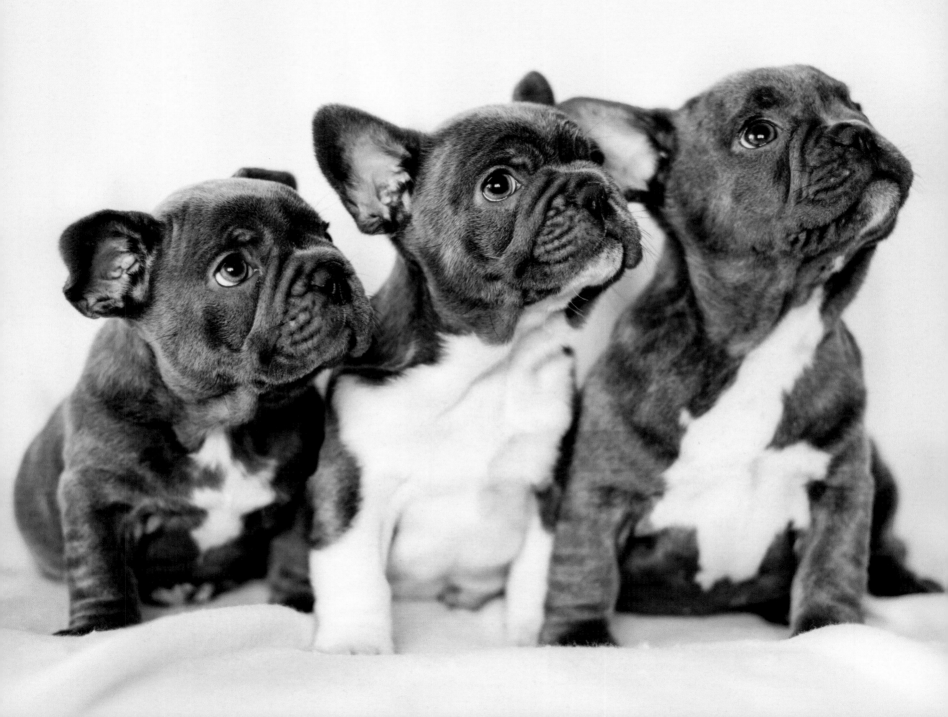

ONLY MY DOGS
WILL NOT BETRAY ME.

MARIA CALLAS

NO MATTER HOW LITTLE MONEY AND HOW FEW POSSESSIONS YOU OWN, HAVING A DOG MAKES YOU RICH.

LOUIS SABIN

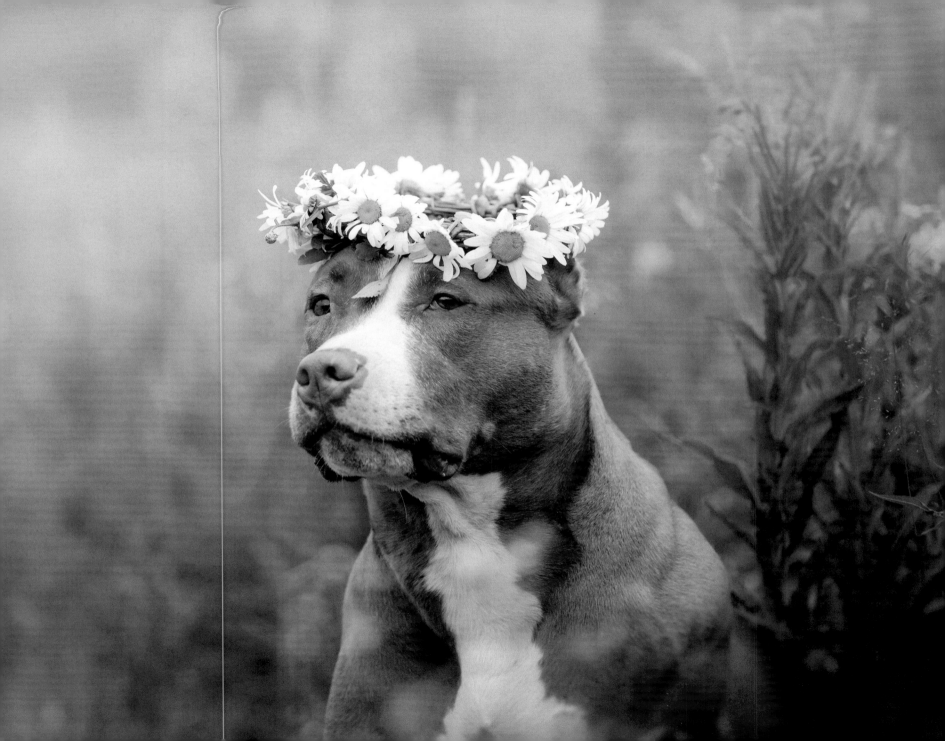

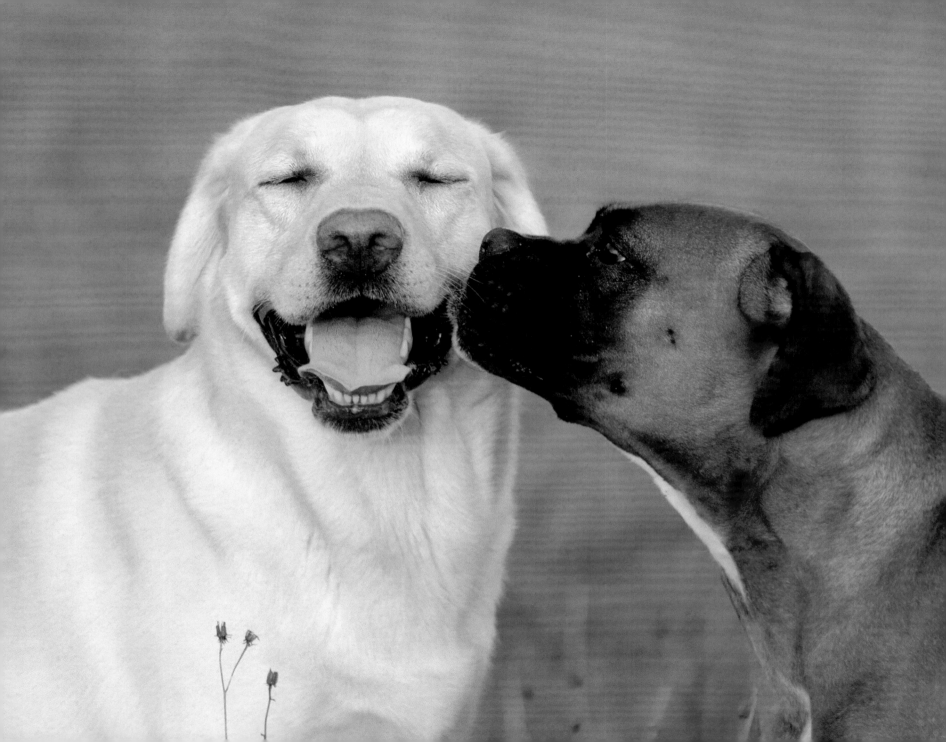

THE LOVE OF A DOG IS A PURE THING.
HE GIVES YOU A TRUST
WHICH IS TOTAL.
YOU MUST NOT BETRAY IT.

MICHEL HOUELLEBECQ

PETTING, SCRATCHING, AND CUDDLING
A DOG COULD BE AS SOOTHING
TO THE MIND AND HEART AS
DEEP MEDITATION, AND ALMOST
AS GOOD FOR THE SOUL AS PRAYER.

DEAN KOONTZ

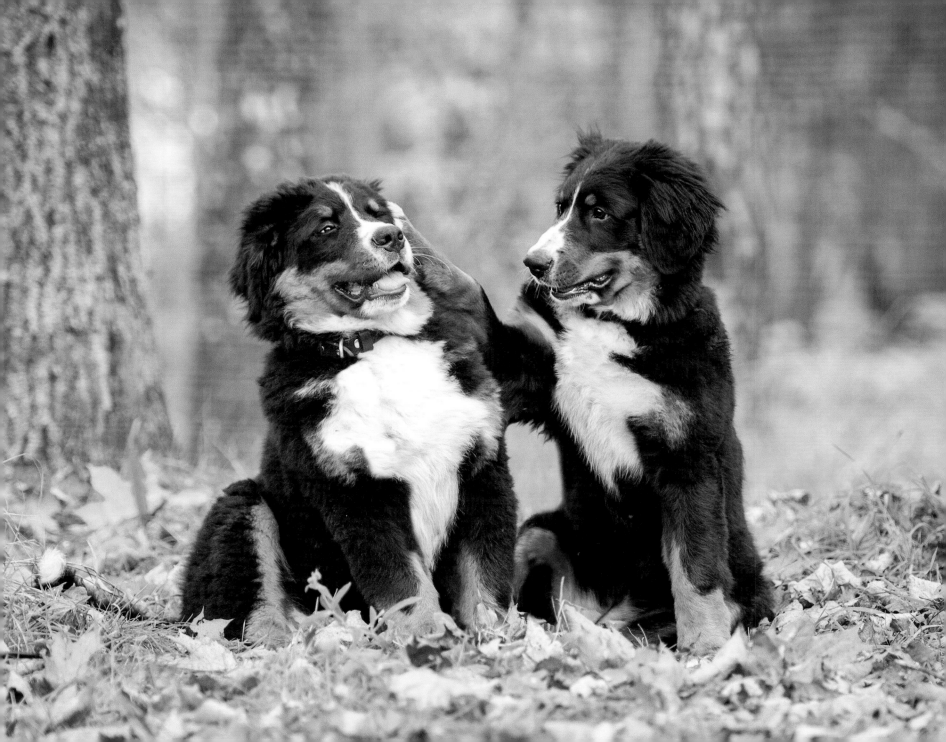

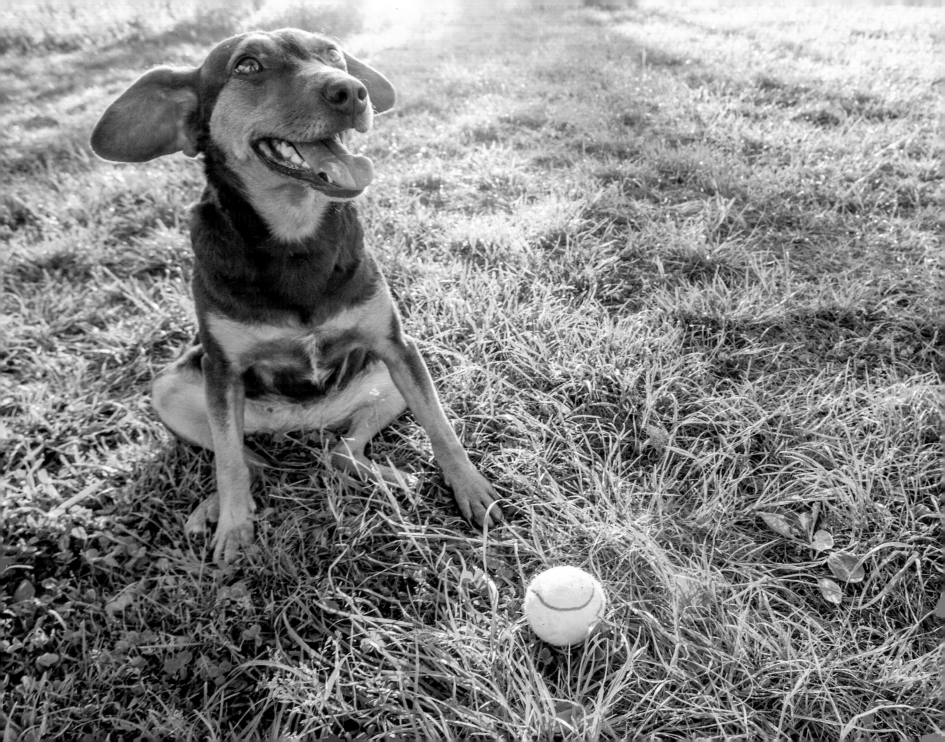

I HAVE FOUND THAT WHEN
YOU ARE DEEPLY TROUBLED,
THERE ARE THINGS YOU GET FROM THE
SILENT DEVOTED COMPANIONSHIP
OF A DOG THAT YOU CAN GET
FROM NO OTHER SOURCE.

DORIS DAY

DOGS HAVE A WAY OF FINDING
THE PEOPLE WHO NEED THEM,
AND FILLING AN EMPTINESS
WE DIDN'T EVER KNOW WE HAD.

THOM JONES

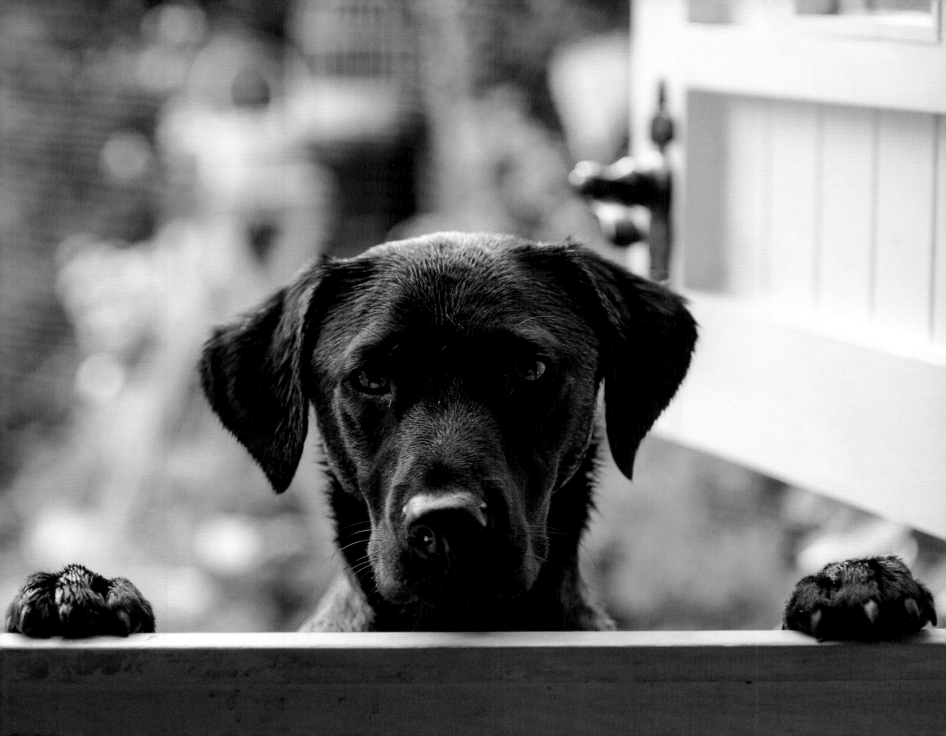

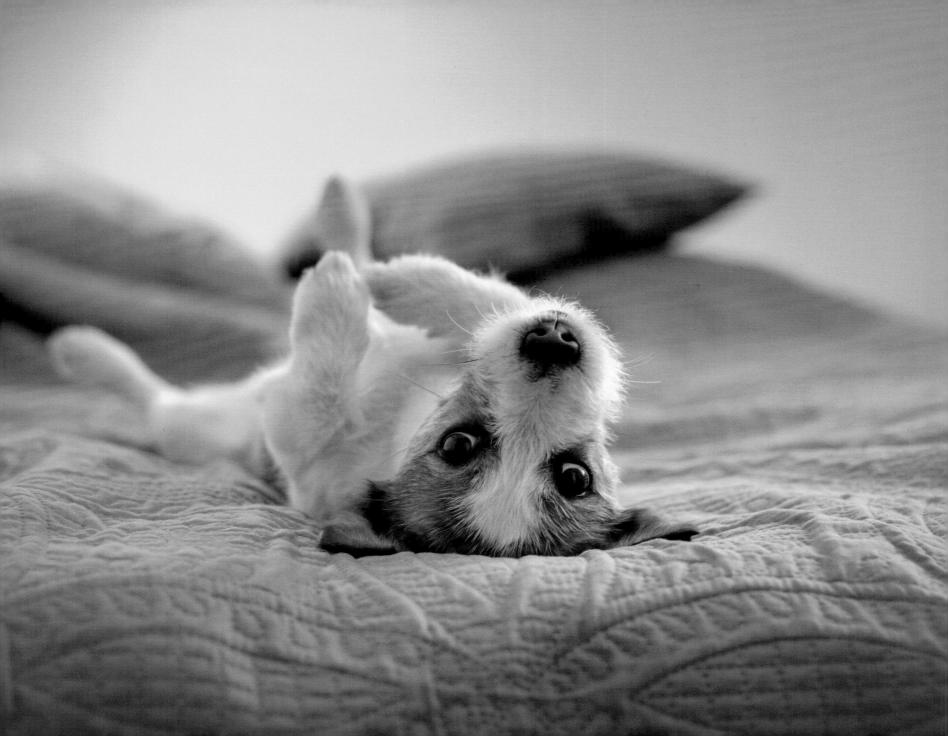

A DOG DOESN'T CARE IF YOU'RE RICH OR POOR, SMART OR DUMB.

GIVE HIM YOUR HEART... AND HE'LL GIVE YOU HIS.

MILO GATHEMA

WHEN AN EIGHTY-FIVE POUND MAMMAL
LICKS YOUR TEARS AWAY,
THEN TRIES TO SIT ON YOUR LAP,
IT'S HARD TO FEEL SAD.

KRISTAN HIGGINS

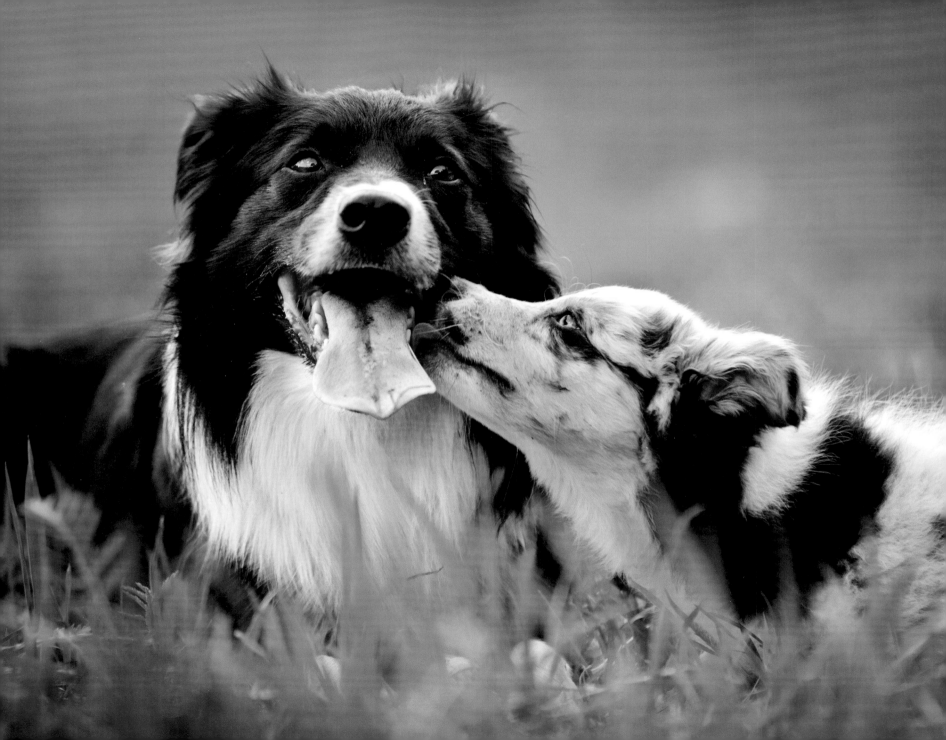

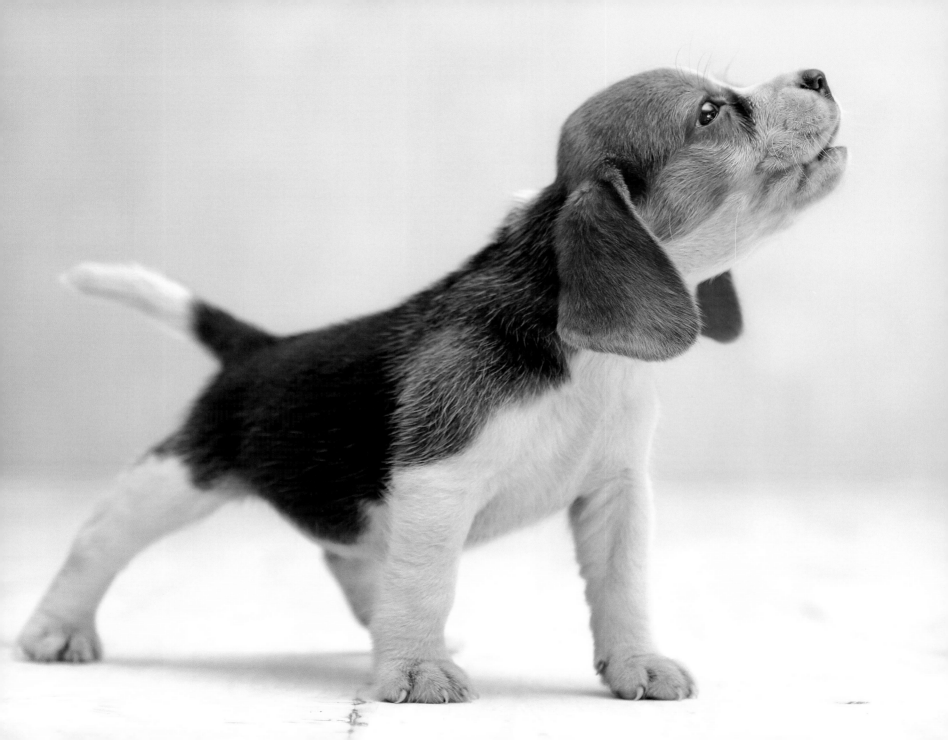

A HOUND WILL DIE FOR YOU, BUT NEVER LIE TO YOU.

GEORGE R. R. MARTIN

ONE REASON A DOG
CAN BE SUCH A COMFORT WHEN
YOU'RE FEELING BLUE IS THAT
HE DOESN'T TRY TO FIND OUT WHY.

UNKNOWN

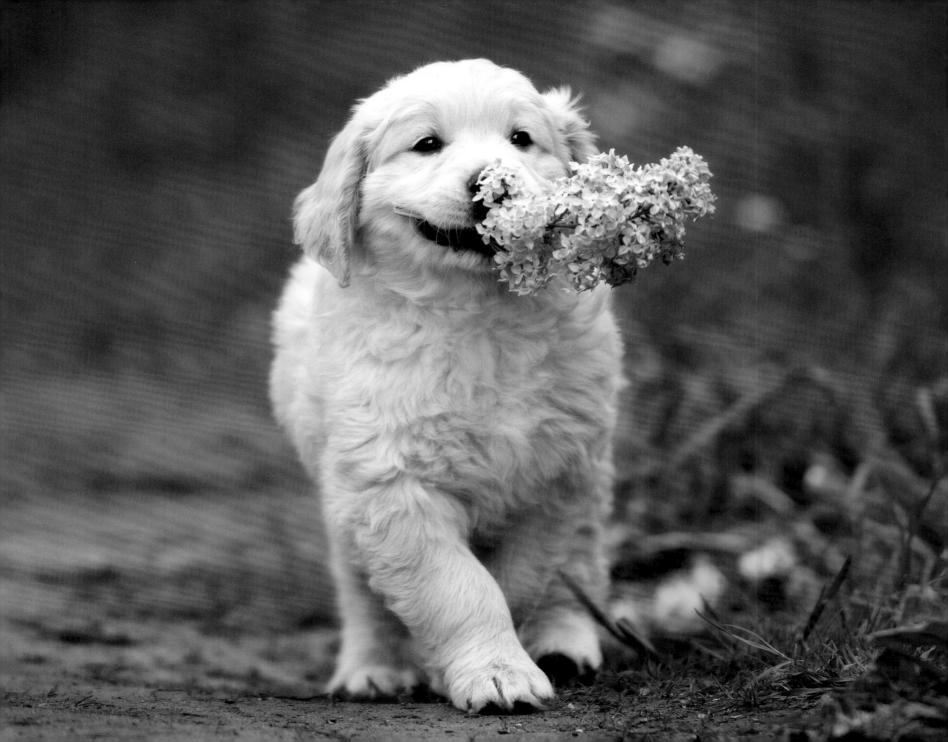

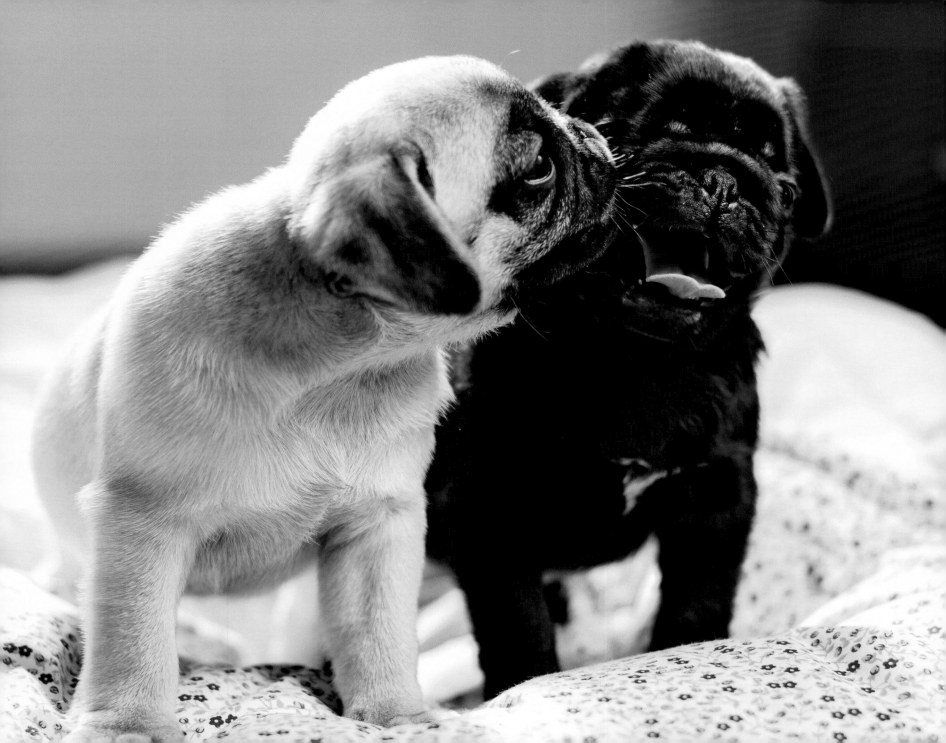

A DOG
IS THE ONLY THING
THAT CAN MEND A CRACK
IN YOUR BROKEN HEART.

JUDY DESMOND

"I'M NOT ALONE,"
SAID THE BOY.
"I'VE GOT A PUPPY."

JANE THAYER

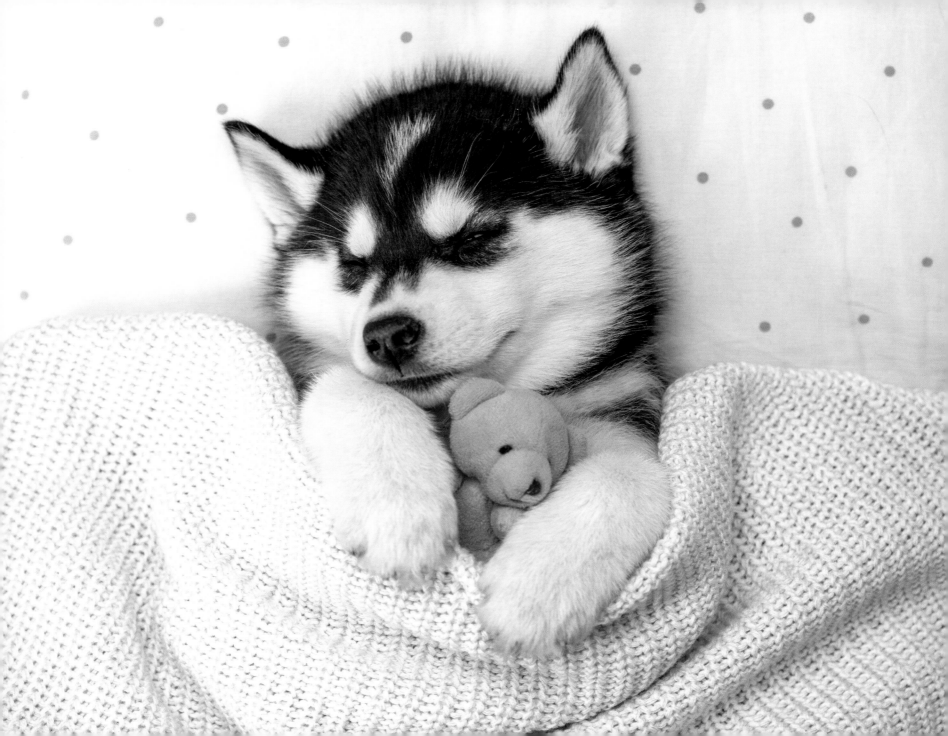

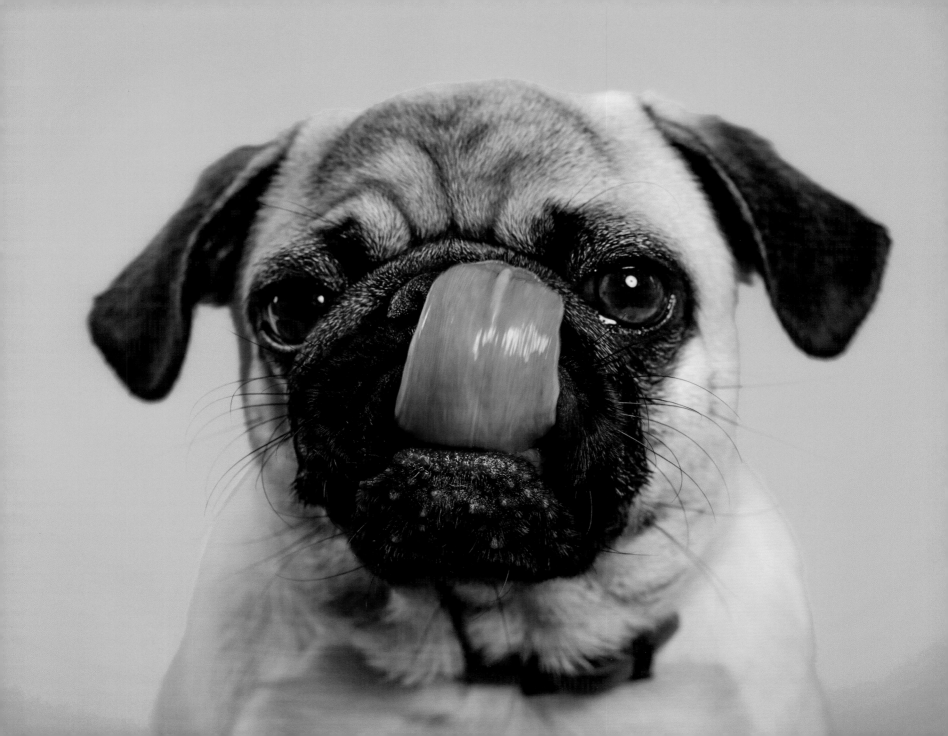

THERE IS NO PSYCHIATRIST IN THE WORLD

LIKE A PUPPY LICKING YOUR FACE.

BEN WILLIAMS

THERE ARE NO ULTERIOR MOTIVES WITH A DOG, NO MIND GAMES, NO SECOND-GUESSING, NO COMPLICATED NEGOTIATIONS OR BARGAINS, AND NO GUILT TRIPS OR GRUDGES IF A REQUEST IS DENIED.

CAROLINE KNAPP

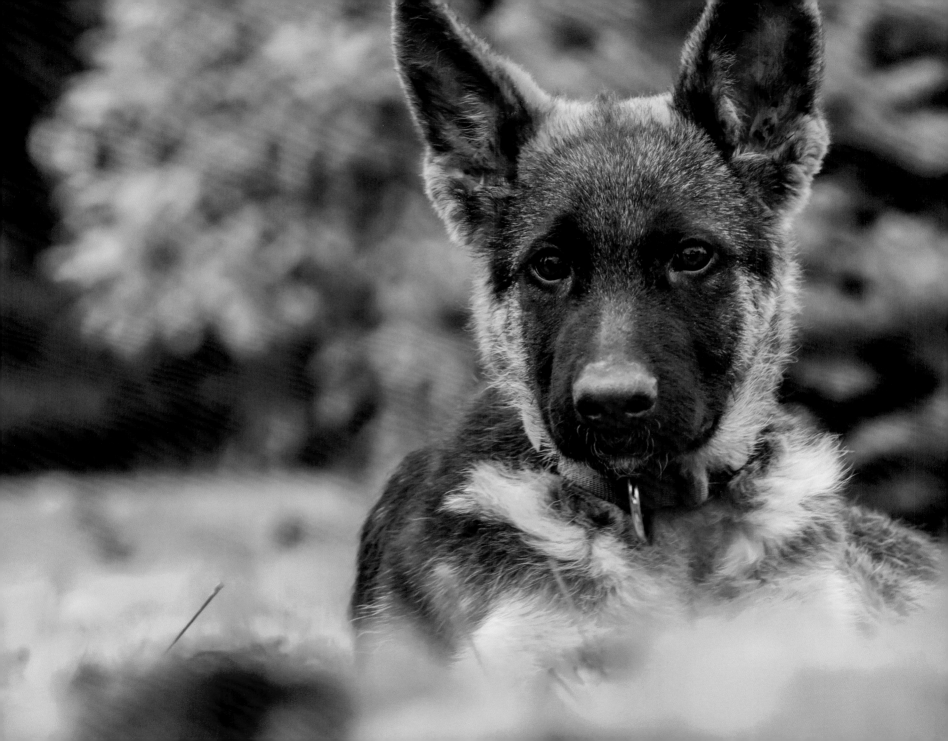

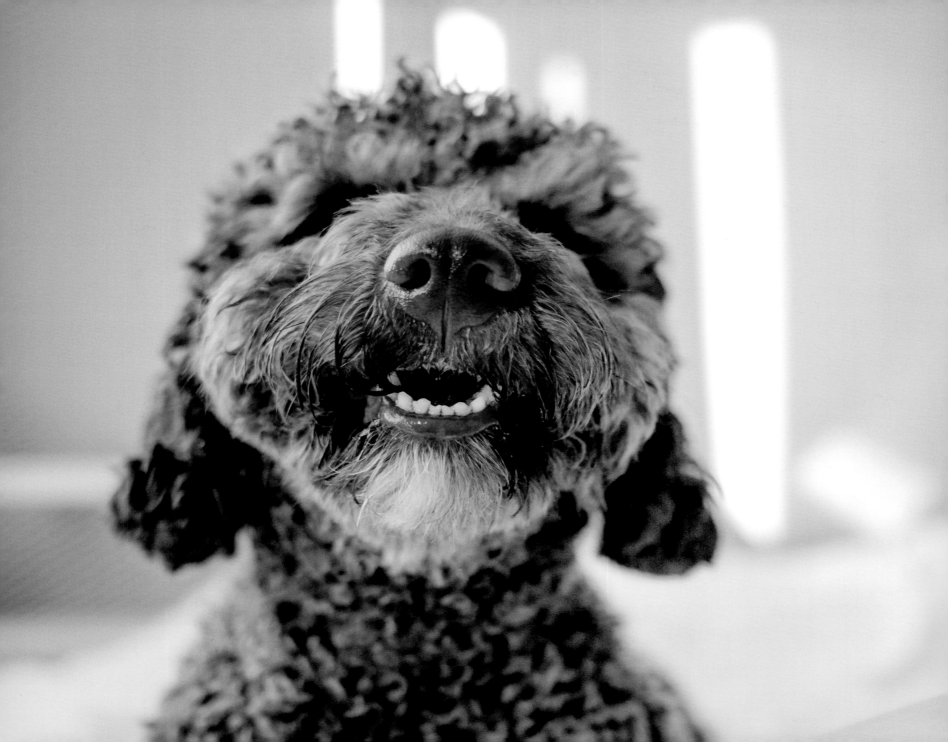

ONCE YOU HAVE HAD A WONDERFUL DOG, A LIFE WITHOUT ONE IS A LIFE DIMINISHED.

DEAN KOONTZ

THE GREATEST PLEASURE OF A DOG IS THAT YOU MAY MAKE A FOOL OF YOURSELF WITH HIM,

AND NOT ONLY WILL HE NOT SCOLD YOU, BUT HE WILL MAKE A FOOL OF HIMSELF, TOO.

SAMUEL BUTLER

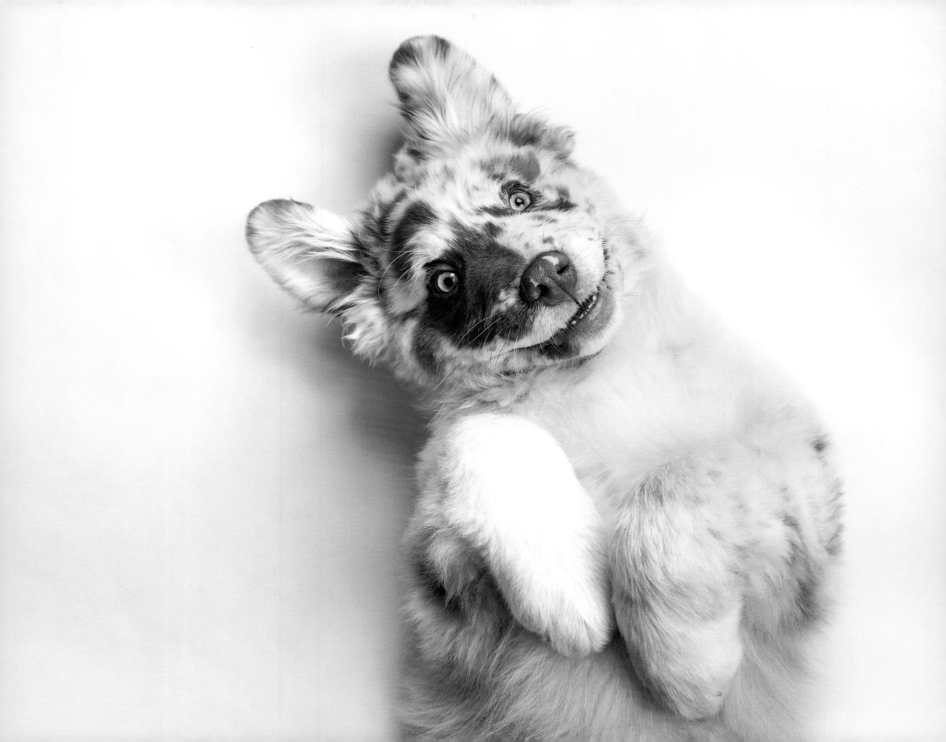

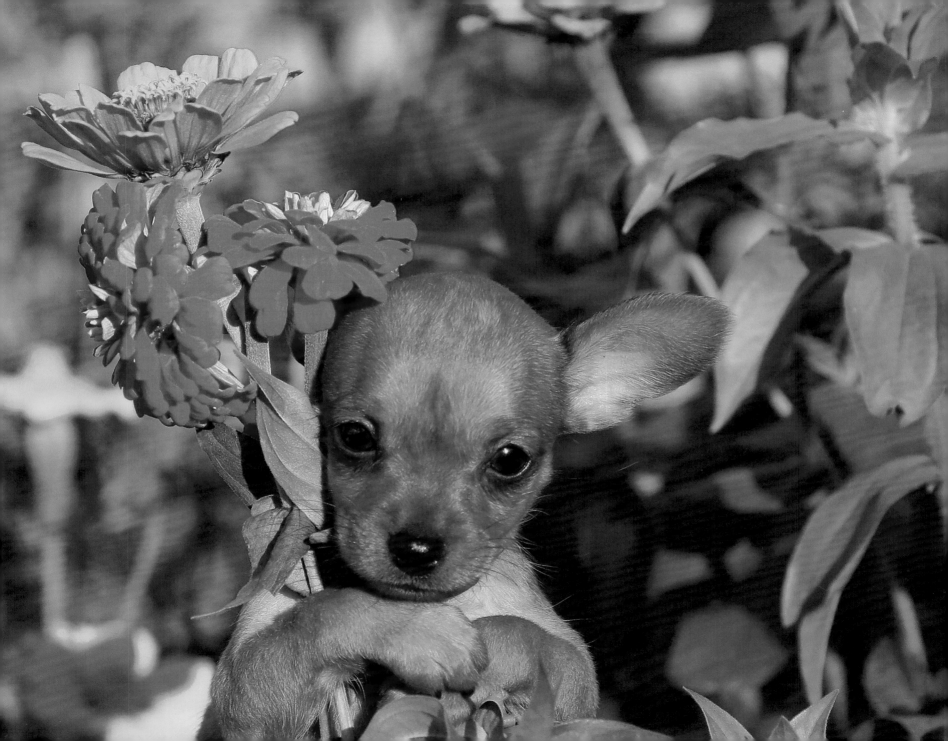

DID YOU KNOW THAT THERE ARE OVER 300 WORDS FOR LOVE IN CANINE?

GABRIELLE ZEVIN

BE THE PERSON
YOUR DOG THINKS YOU ARE.

C.J. FRICK

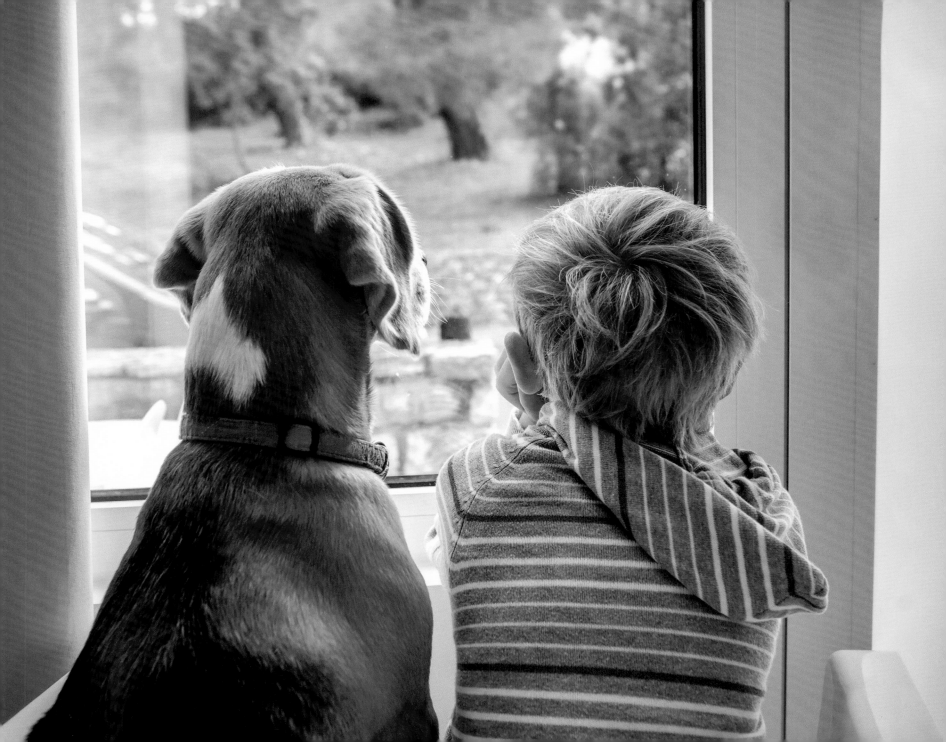

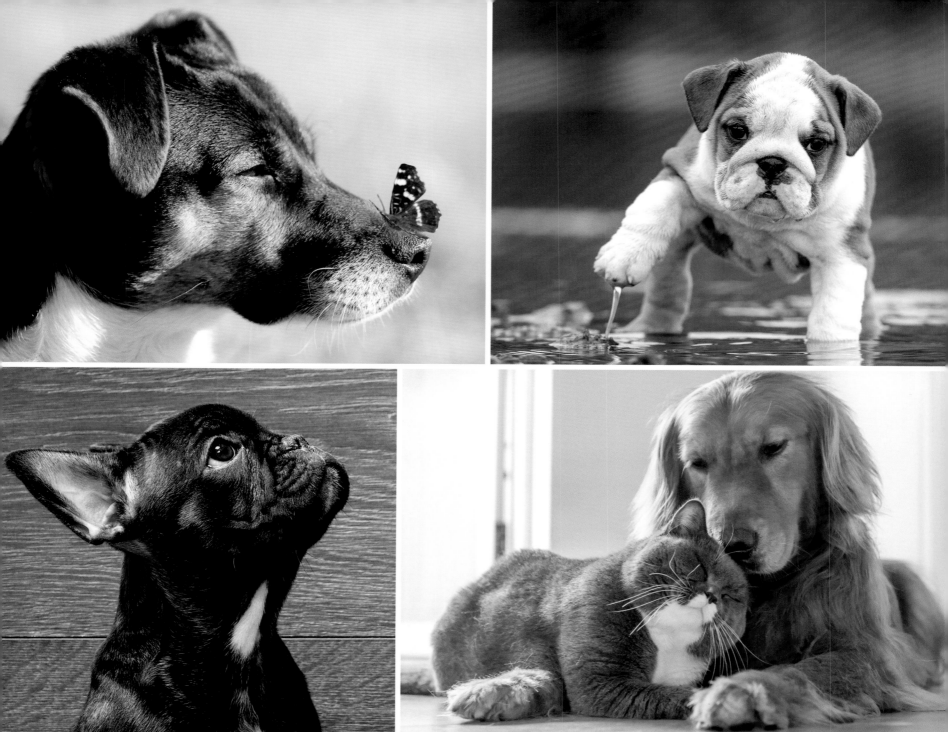

VERY GOOD
DOGS

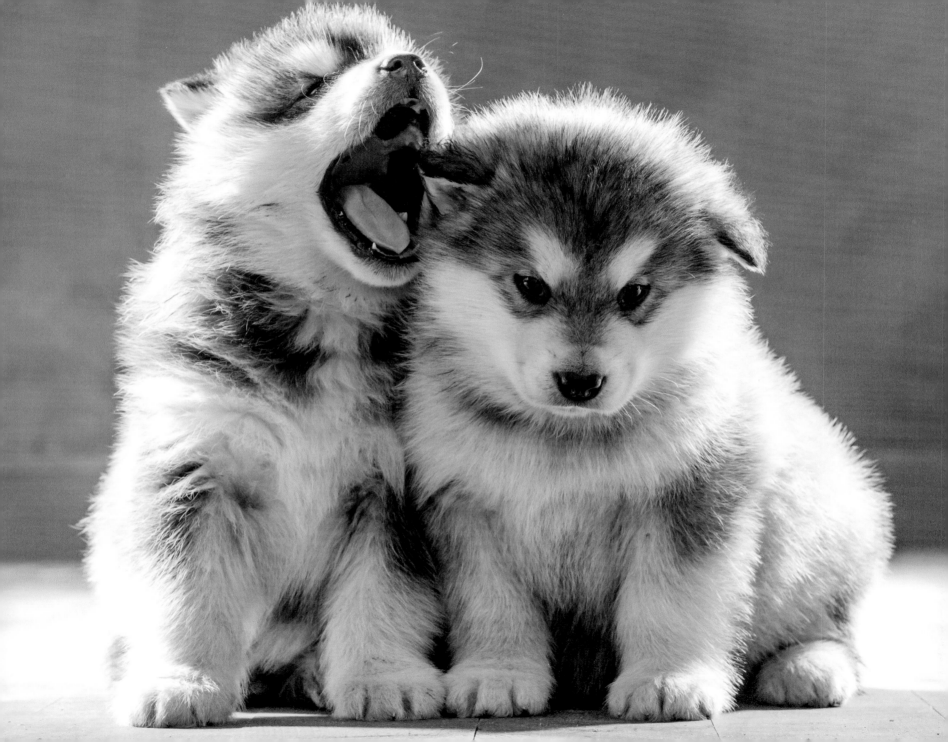

DOGS NEVER BITE ME.
JUST HUMANS.

MARILYN MONROE

I THINK DOGS ARE THE
MOST AMAZING CREATURES;
THEY GIVE UNCONDITIONAL LOVE.
FOR ME, THEY ARE THE ROLE
MODEL FOR BEING ALIVE.

GILDA RADNER

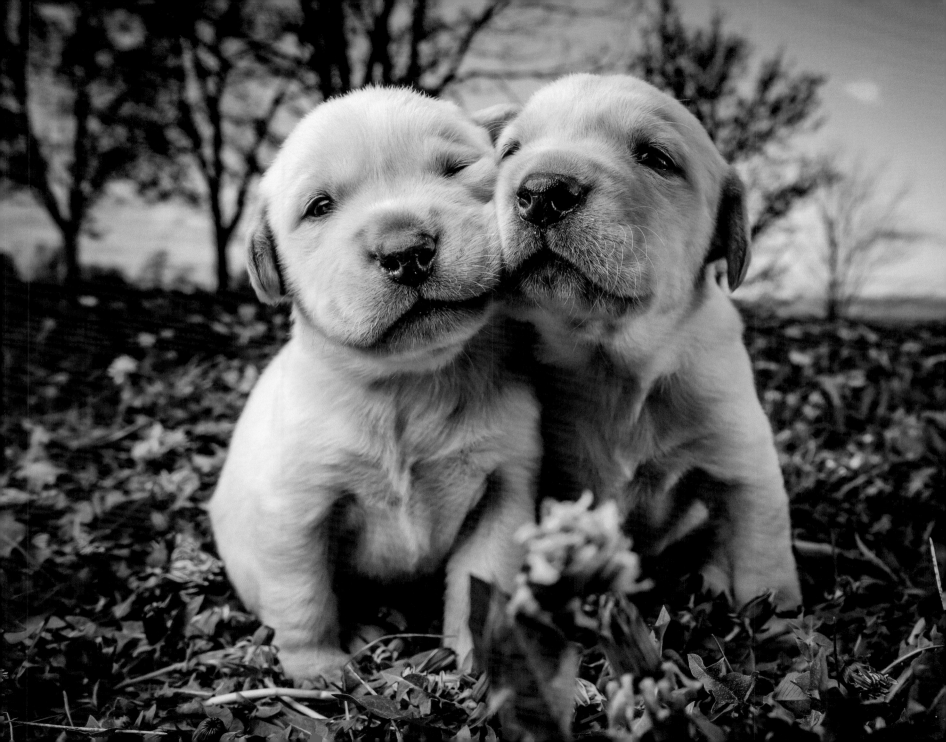

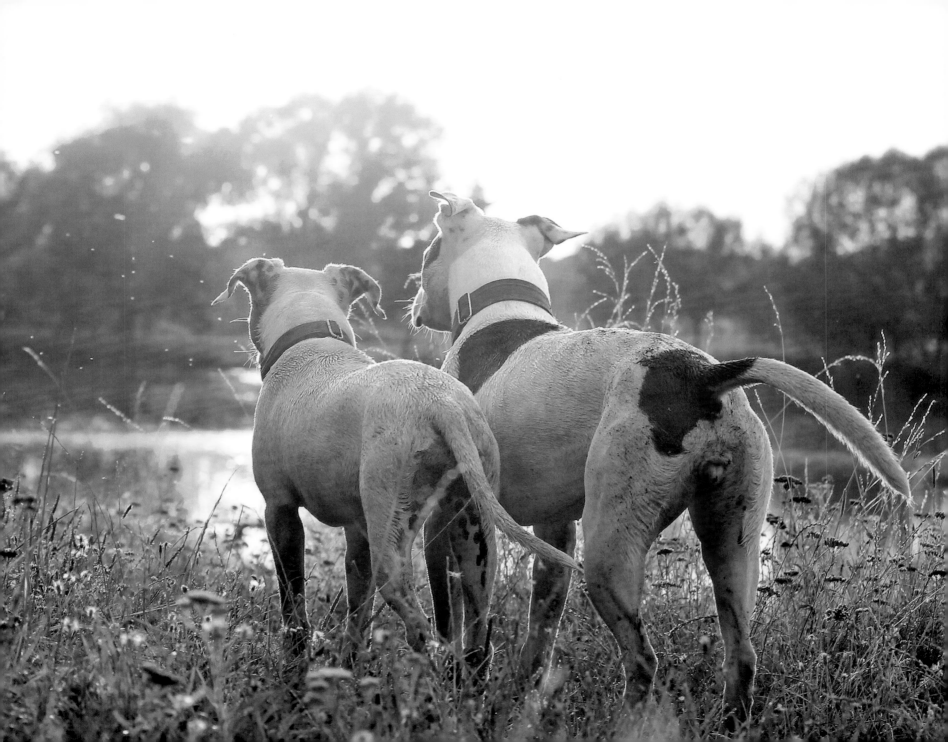

IF THERE ARE NO DOGS IN HEAVEN,
THEN WHEN I DIE I WANT
TO GO WHERE THEY WENT.

WILL ROGERS

DOGS ARE GREAT.

BAD DOGS, IF YOU CAN REALLY CALL THEM THAT, ARE PERHAPS THE GREATEST OF THEM ALL.

JOHN GROGAN

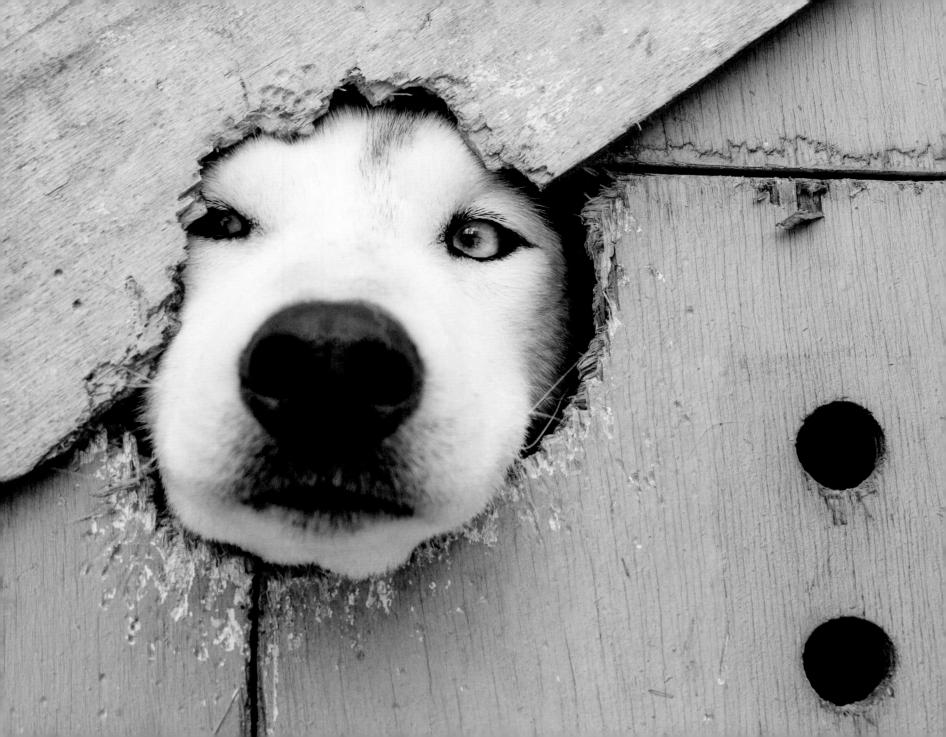

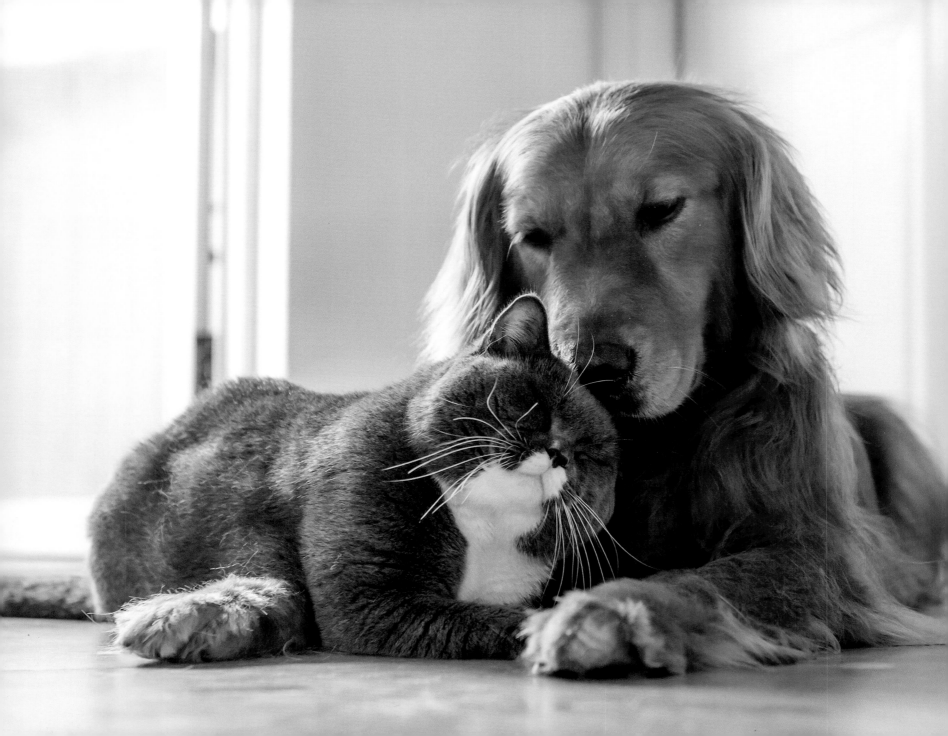

THE AVERAGE DOG
IS A NICER PERSON
THAN THE AVERAGE PERSON.

ANDY ROONEY

HEAVEN GOES BY FAVOR.
IF IT WENT BY MERIT, YOU WOULD STAY OUT AND YOUR DOG WOULD GO IN.

MARK TWAIN

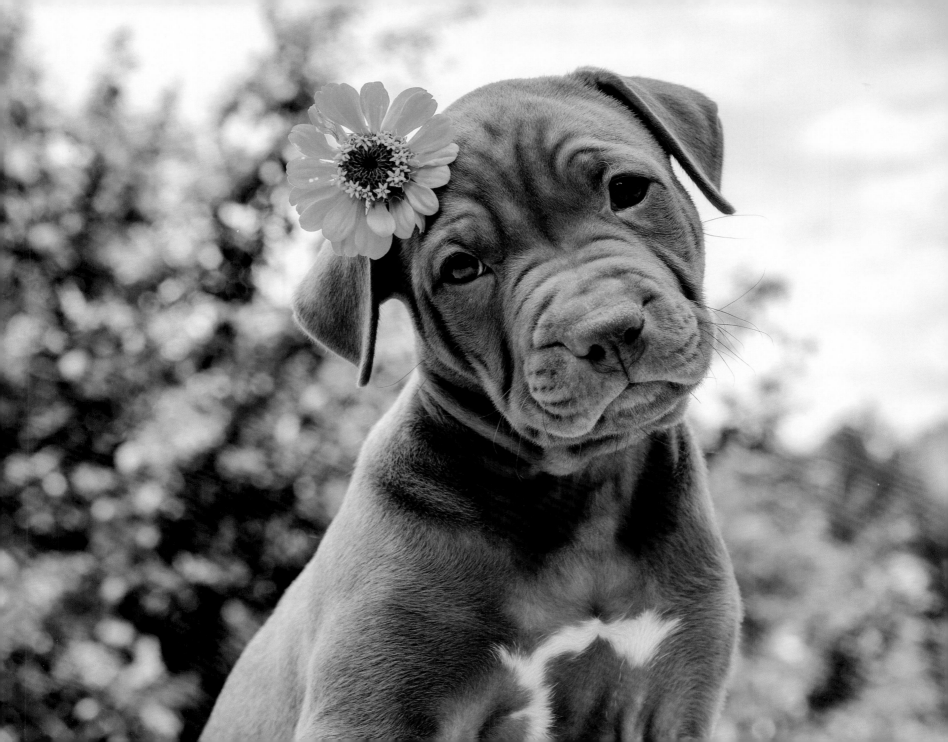

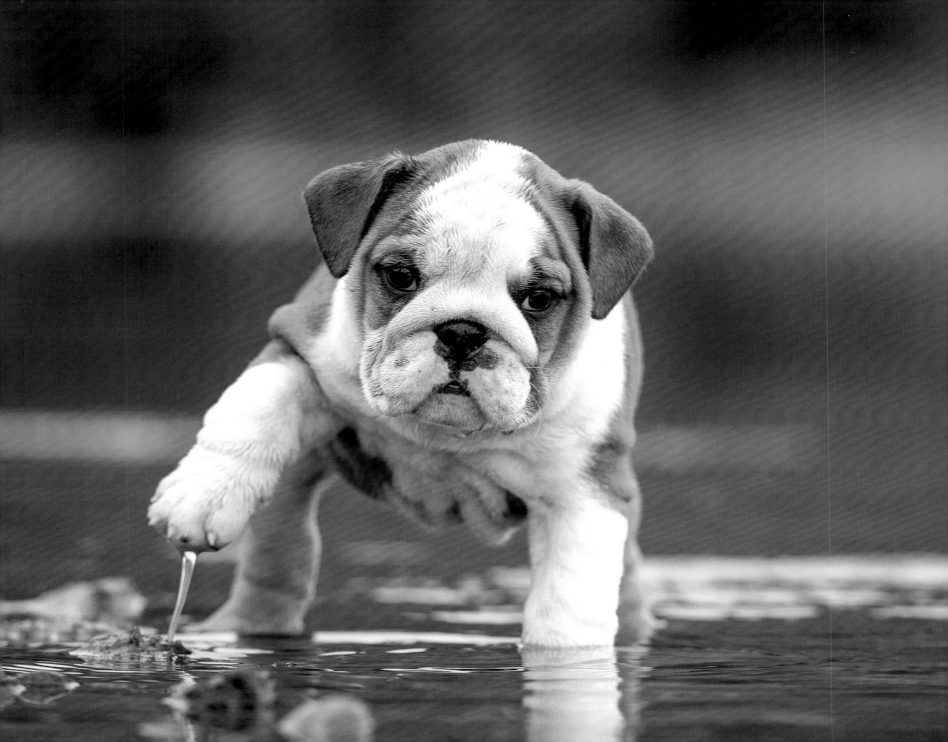

IF A DOG WILL NOT COME TO YOU AFTER HAVING LOOKED YOU IN THE FACE, **YOU SHOULD GO HOME AND EXAMINE YOUR CONSCIENCE.**

WOODROW WILSON

DOGS ARE WISE.
THEY CRAWL AWAY INTO A QUIET CORNER AND LICK THEIR WOUNDS
AND DO NOT REJOIN THE WORLD UNTIL THEY ARE WHOLE ONCE MORE.

AGATHA CHRISTIE

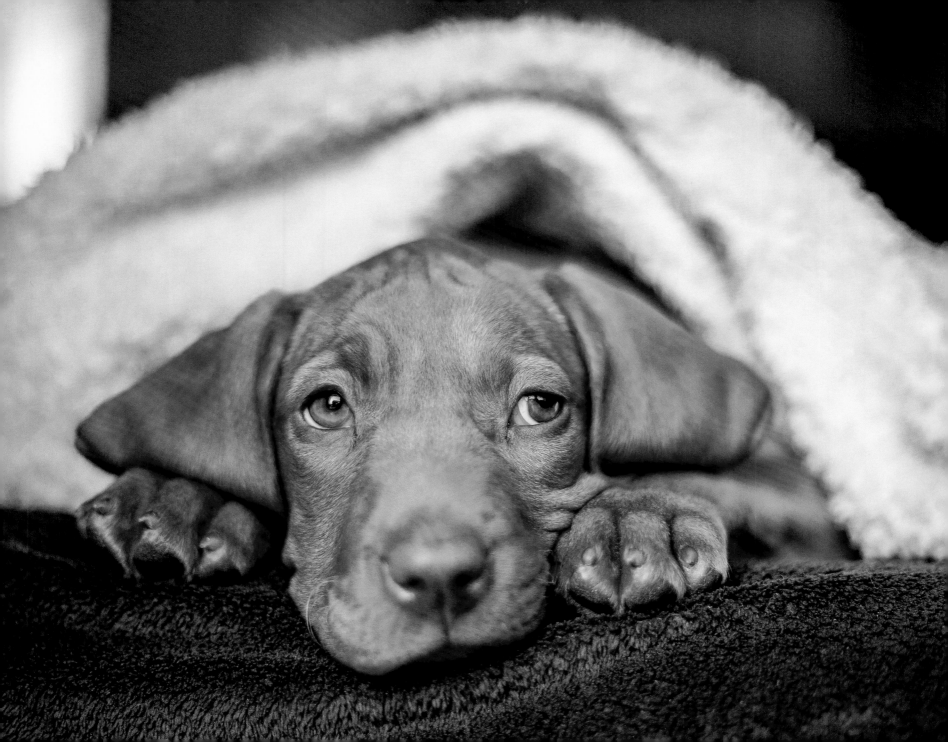

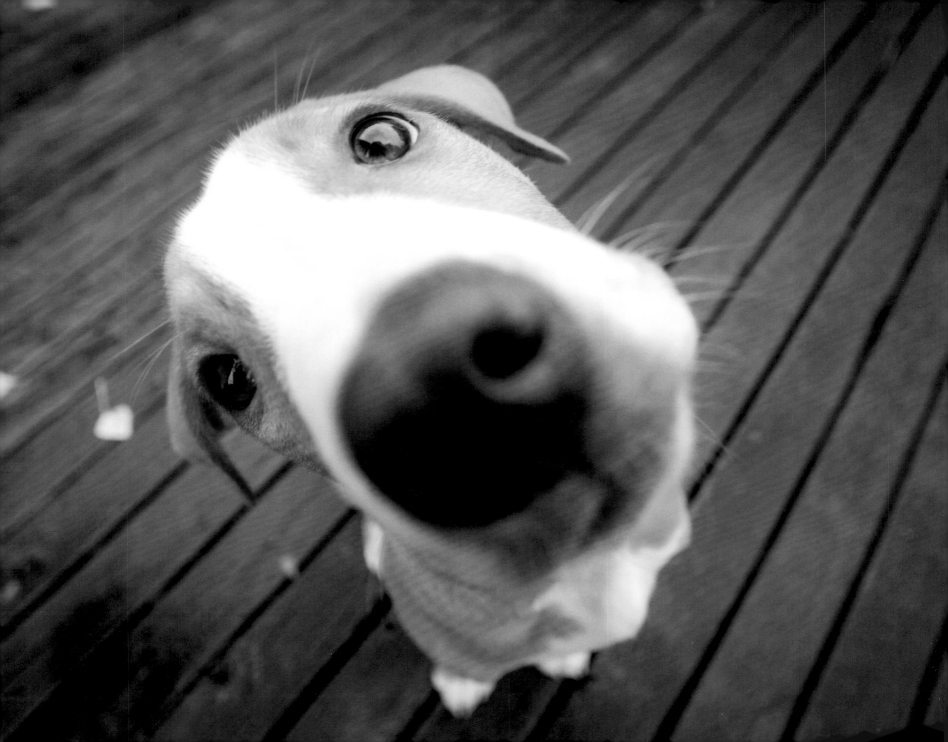

YOU CAN SAY ANY FOOLISH THING TO A DOG, AND THE DOG WILL GIVE YOU A LOOK THAT SAYS, "WOW, YOU'RE RIGHT! I NEVER WOULD'VE THOUGHT OF THAT!"

DAVE BARRY

DOGS DON'T RATIONALIZE. THEY DON'T HOLD ANYTHING AGAINST A PERSON. THEY DON'T SEE THE OUTSIDE OF A HUMAN BUT THE INSIDE OF A HUMAN.

CESAR MILLAN

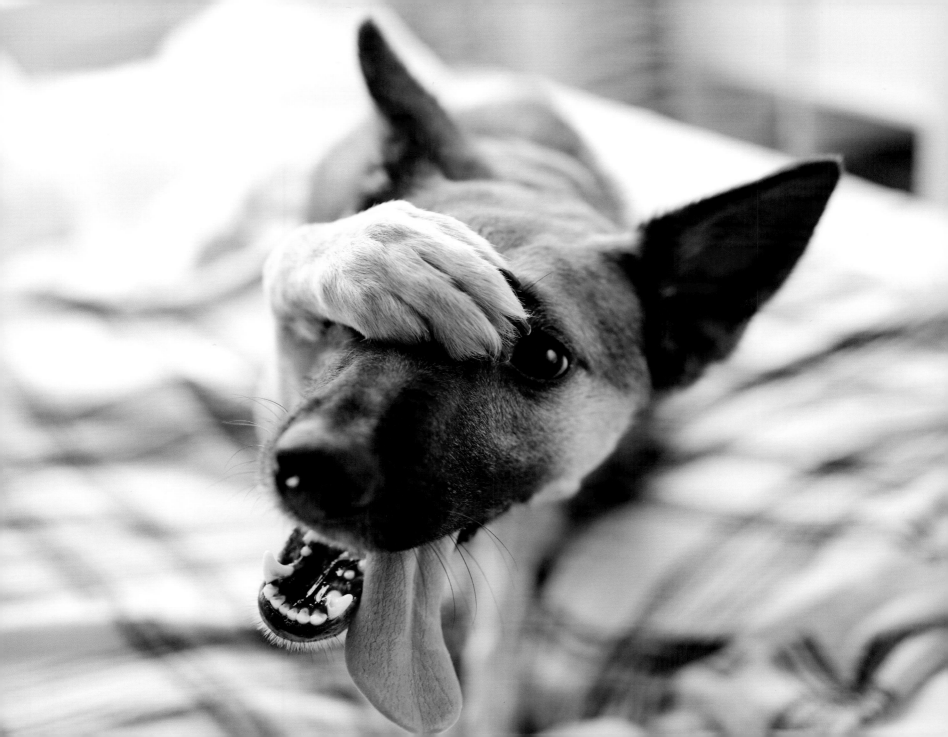

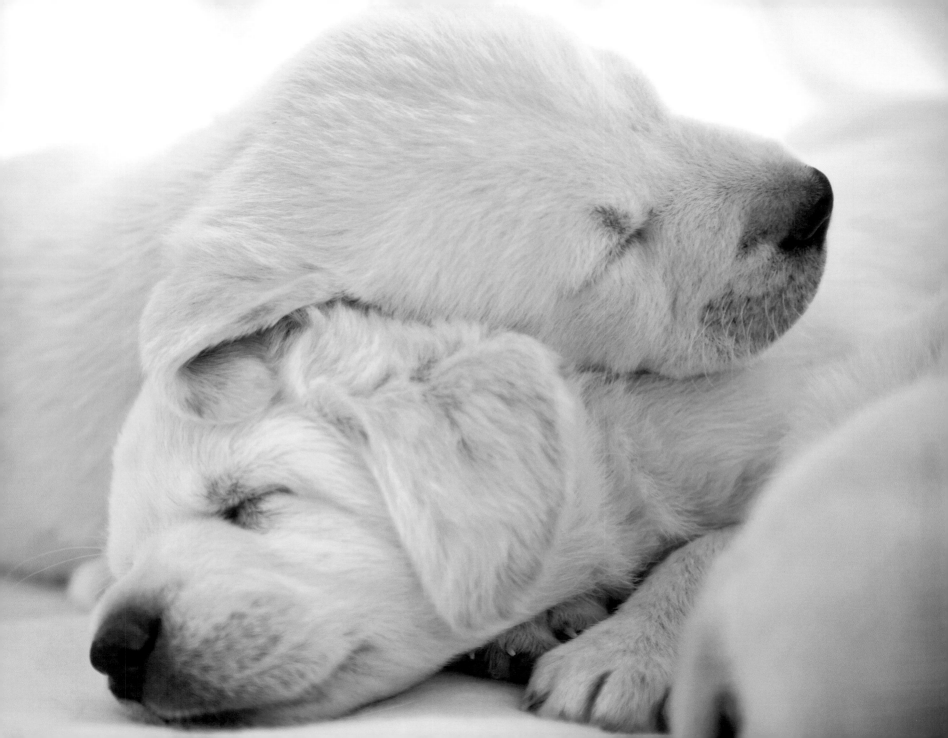

THERE IS NOTHING TRUER IN THIS WORLD THAN THE LOVE OF A GOOD DOG.

MIRA GRANT

DOGS ARE OUR LINK TO PARADISE. THEY DON'T KNOW EVIL OR JEALOUSY OR DISCONTENT.

MILAN KUNDERA

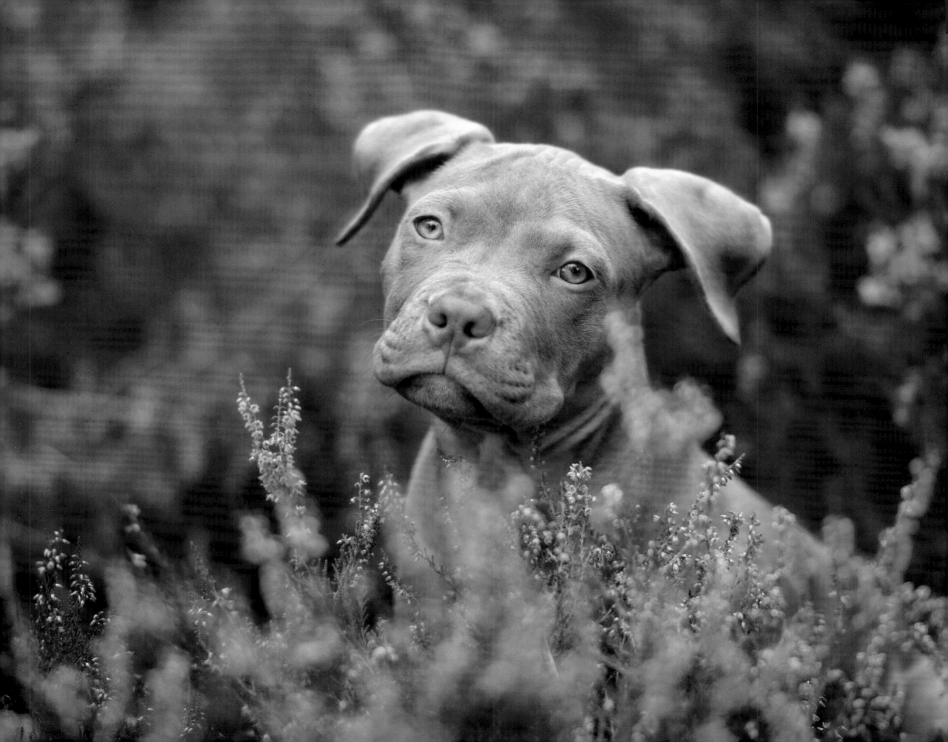

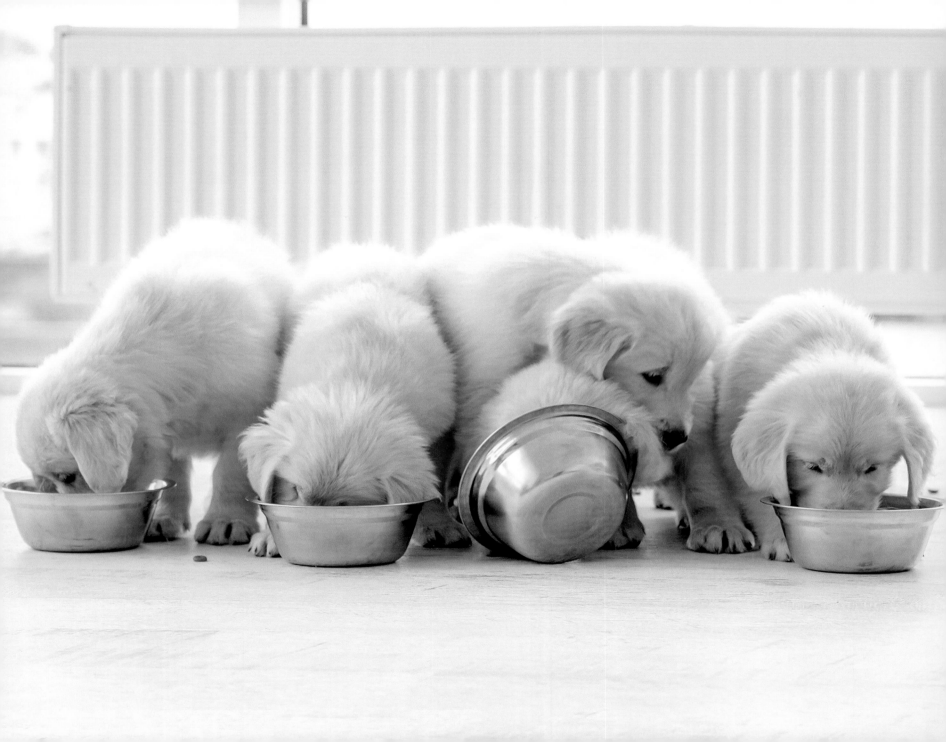

DOGS REALLY ARE PERFECT SOLDIERS.
THEY ARE BRAVE AND SMART,
THEY CAN SMELL THROUGH WALLS,
SEE IN THE DARK, AND EAT ARMY
RATIONS WITHOUT COMPLAINT.

SUSAN ORLEAN

I BELIEVE IN INTEGRITY.
DOGS HAVE IT.
HUMANS ARE SOMETIMES
LACKING IT.

CESAR MILLAN

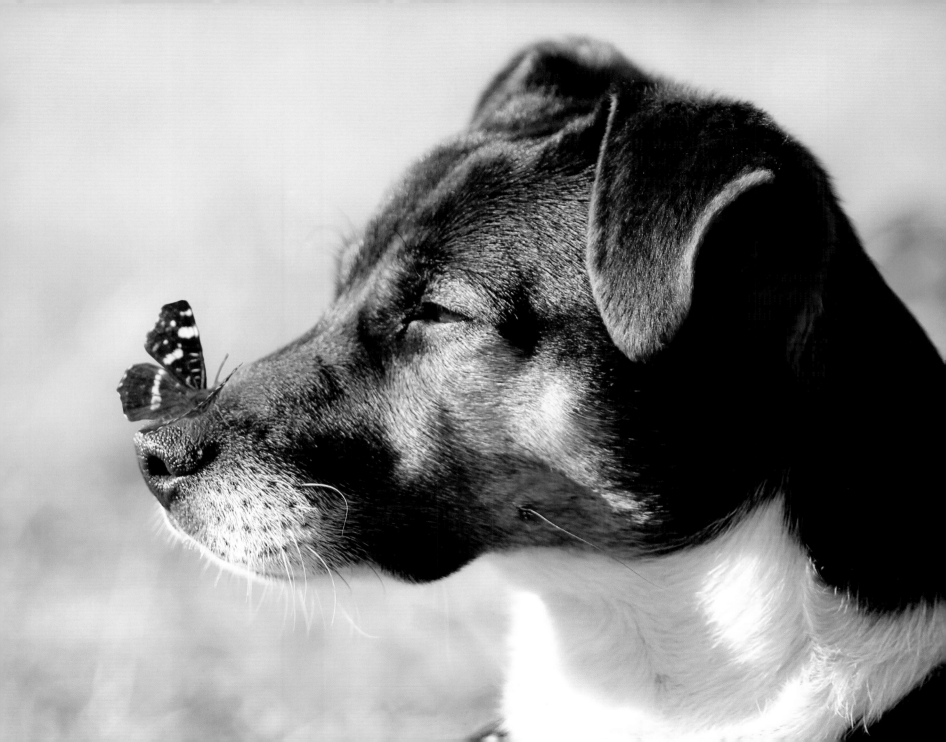

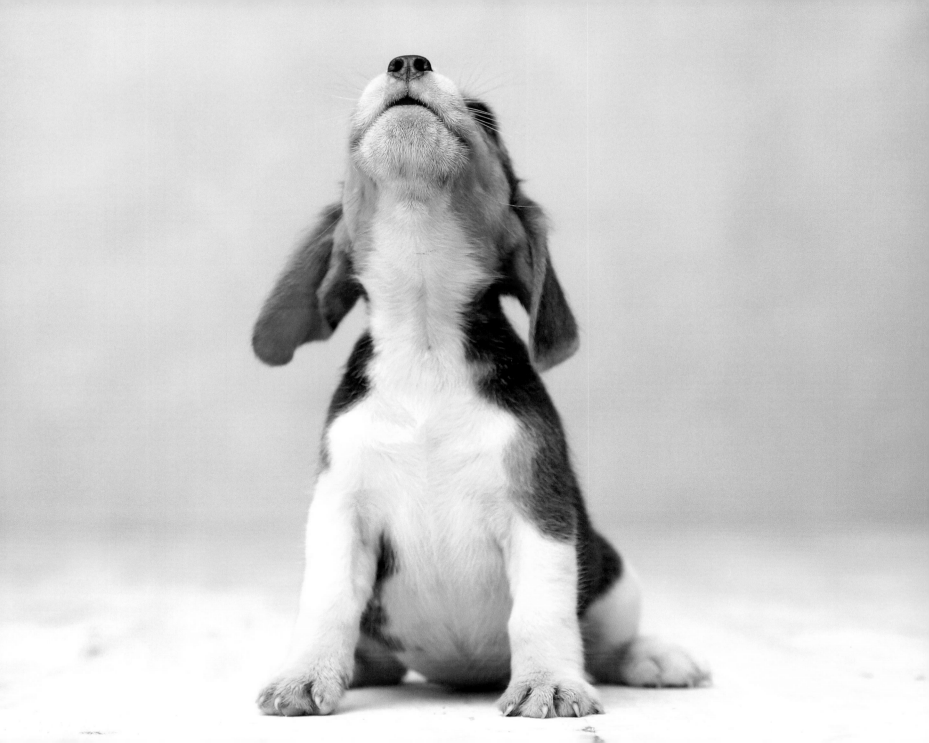

DOGS ARE THE BEST EXAMPLE OF A BEING WHO DOESN'T NEED TO LIE TO PROTECT SOMEONE'S PRIDE.

AMMIEL JOSIAH MONTERDE

DOGS' LIVES ARE TOO SHORT.
THEIR ONLY FAULT, REALLY.

AGNES SLIGH TURNBULL

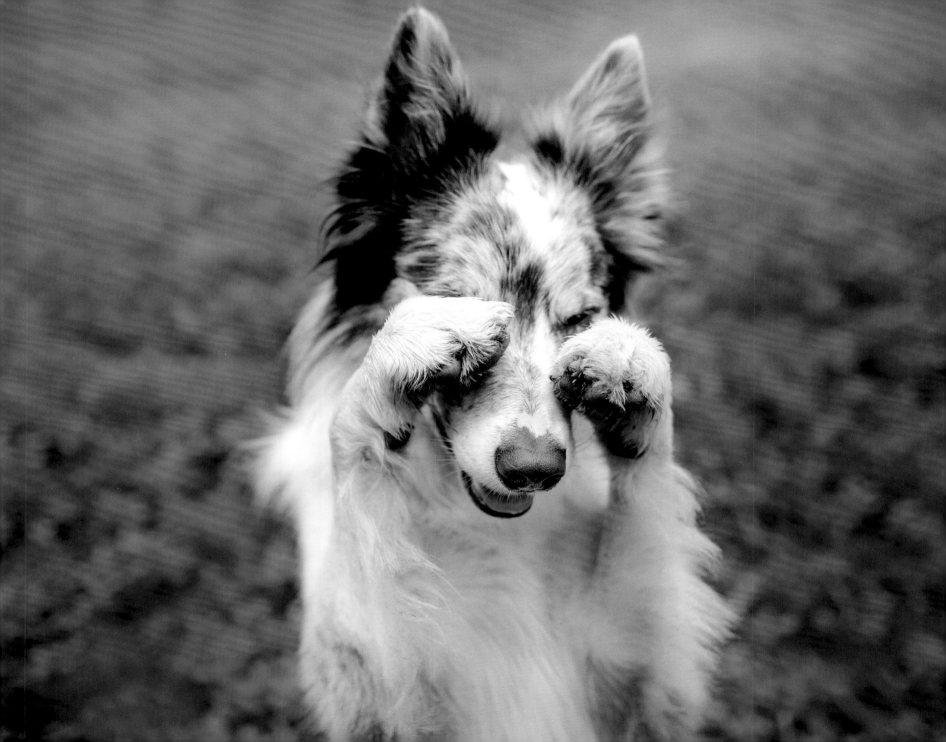

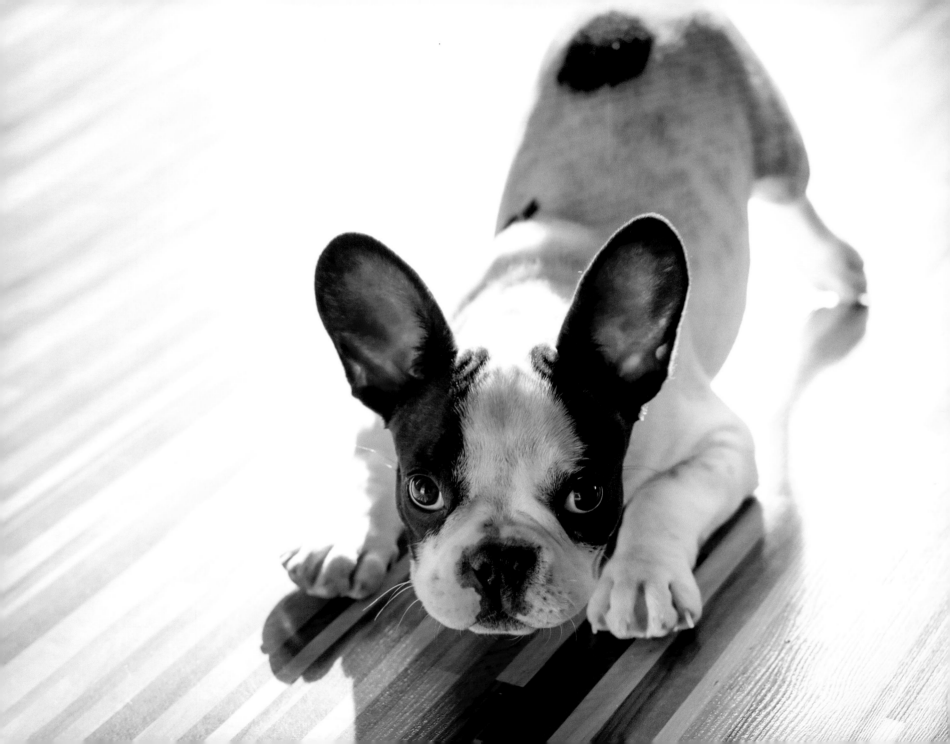

I'M SUSPICIOUS OF PEOPLE WHO DON'T LIKE DOGS,

BUT I TRUST A DOG WHEN IT DOESN'T LIKE A PERSON.

BILL MURRAY

MANY OF THE QUALITIES THAT COME
SO EFFORTLESSLY TO DOGS—
LOYALTY, DEVOTION, SELFLESSNESS,
UNFLAGGING OPTIMISM, UNQUALIFIED LOVE—
CAN BE ELUSIVE TO HUMANS.

JOHN GROGAN

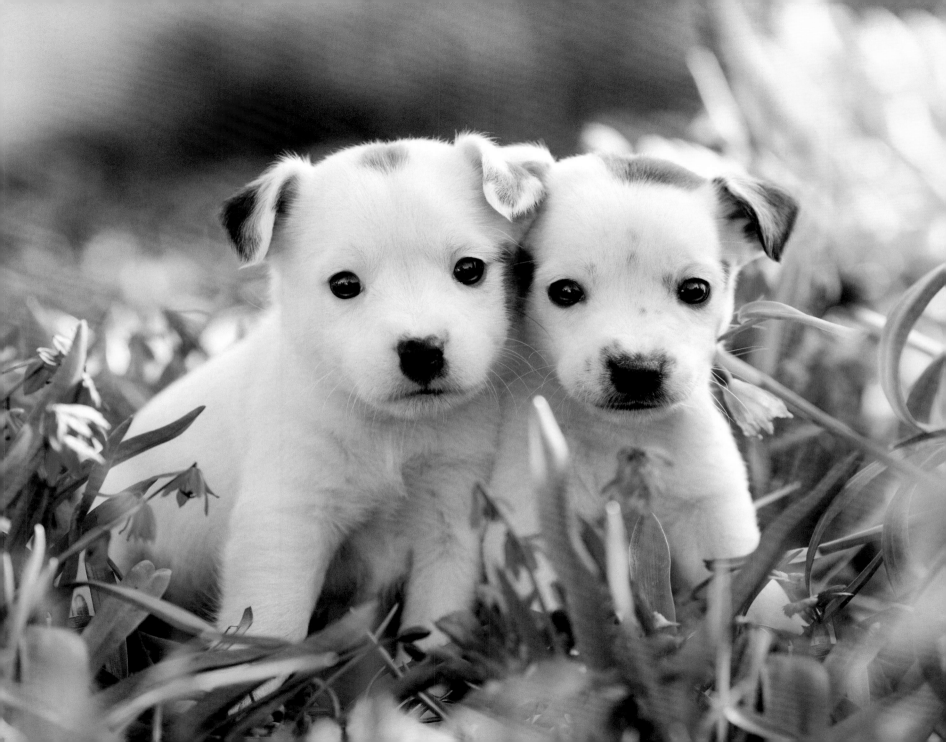

QUESTERS OF THE TRUTH,
THAT'S WHO DOGS ARE;
SEEKERS AFTER THE INVISIBLE SCENT
OF ANOTHER BEING'S AUTHENTIC CORE.

JEFFREY MOUSSAIEFF MASSON

JOYFUL, JOYFUL, JOYFUL,
AS ONLY DOGS KNOW HOW TO BE HAPPY
WITH ONLY THE AUTONOMY OF
THEIR SHAMELESS SPIRIT.

DOGS ARE BETTER THAN HUMAN BEINGS

BECAUSE THEY KNOW BUT DO NOT TELL.

EMILY DICKINSON

ALL HIS LIFE HE TRIED
TO BE A GOOD PERSON.
MANY TIMES, HOWEVER, HE FAILED.
FOR AFTER ALL, HE WAS ONLY HUMAN.
HE WASN'T A DOG.

CHARLES M. SCHULZ

132

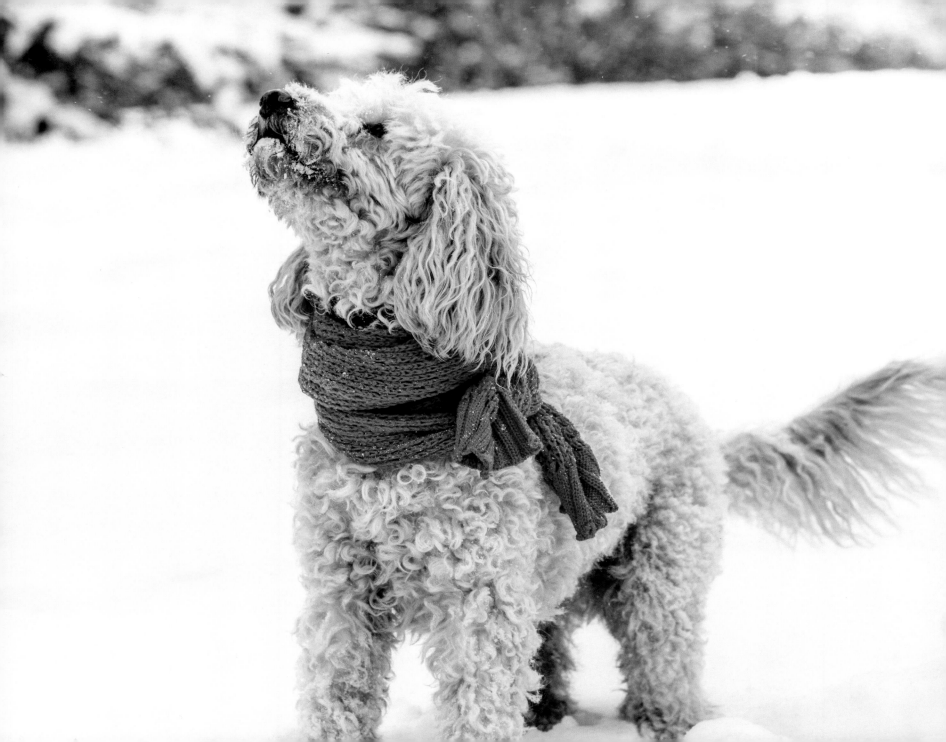

BOOPS, BARKS &
BEST IN SHOW

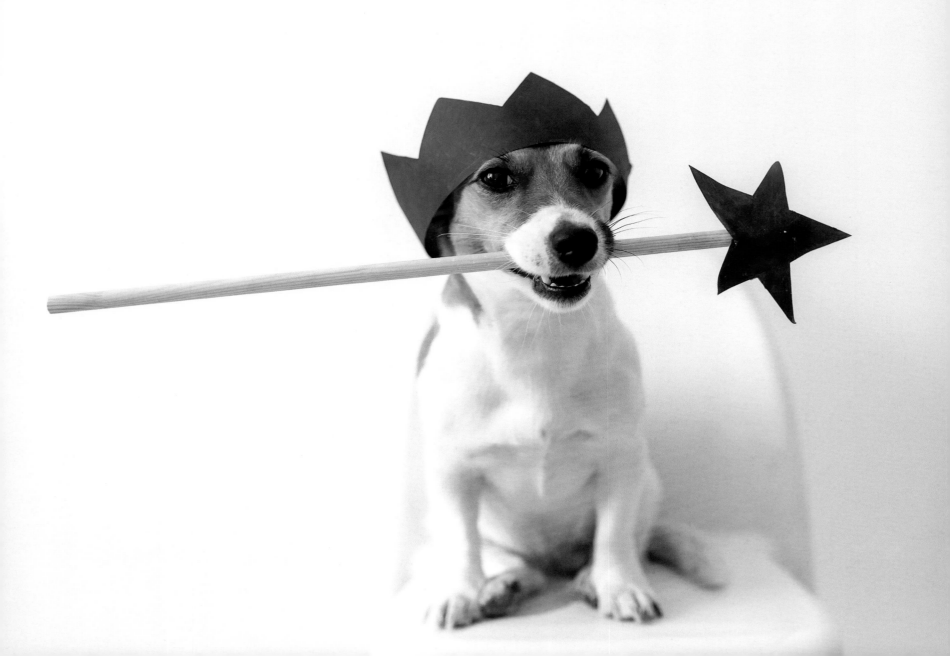

DOGS ARE THE MAGICIANS
OF THE UNIVERSE.

CLARISSA PINKOLA ESTÉS

HAPPINESS
IS A WARM PUPPY.

CHARLES M. SCHULZ

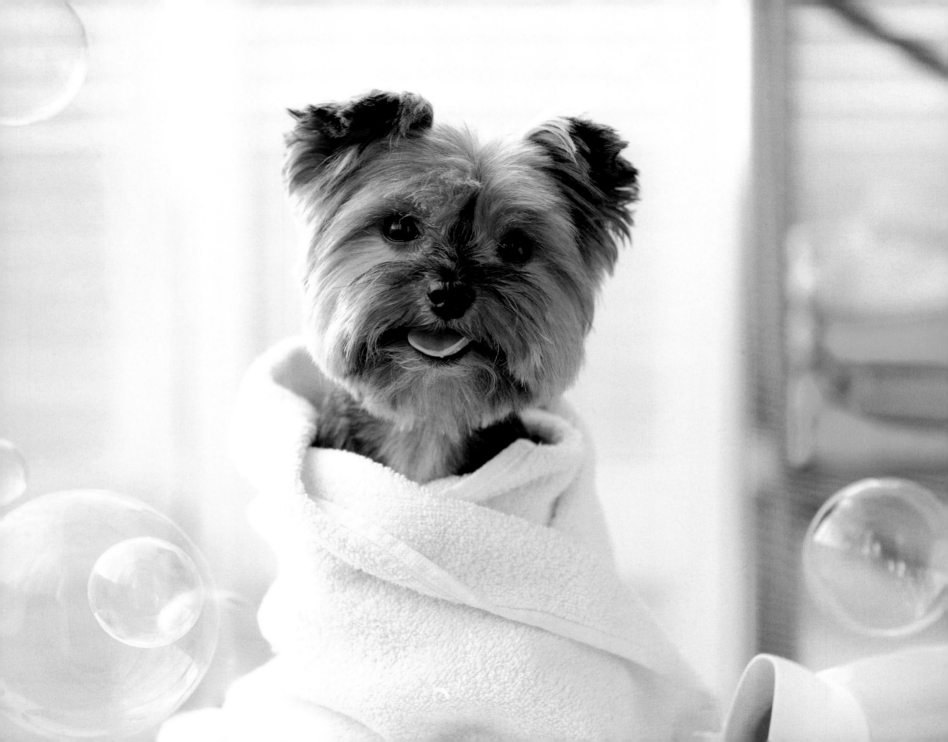

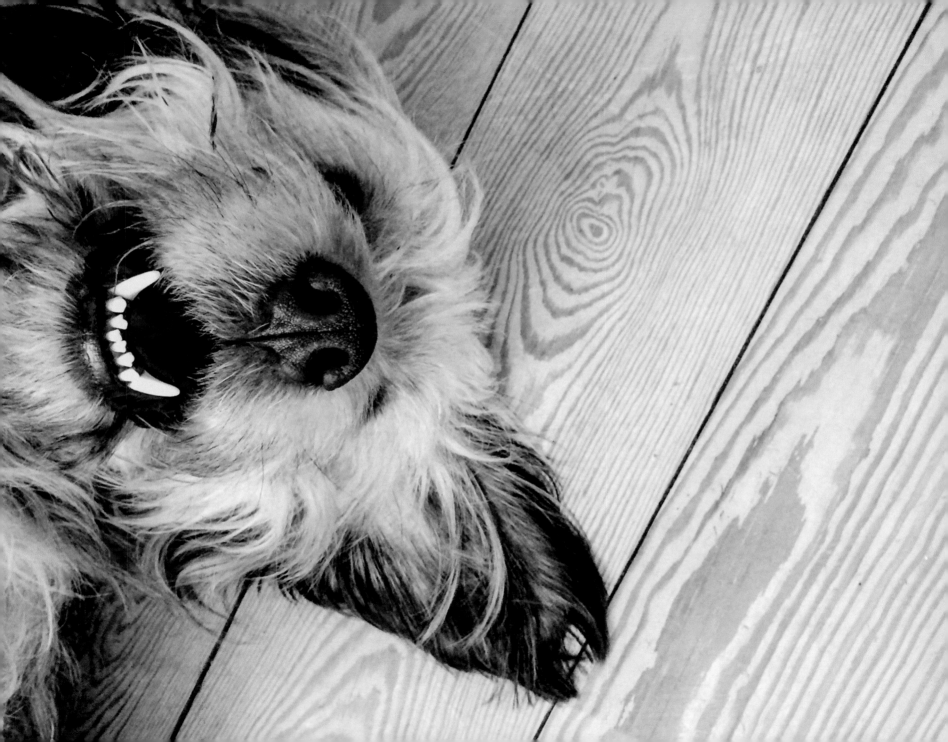

I LIKE DOGS. YOU ALWAYS KNOW WHAT A DOG IS THINKING. **IT HAS FOUR MOODS. HAPPY, SAD, CROSS AND CONCENTRATING.** ALSO, DOGS ARE FAITHFUL AND THEY DO NOT TELL LIES BECAUSE THEY CANNOT TALK.

MARK HADDON

EVERY DOG
MUST HAVE HIS DAY.

JONATHAN SWIFT

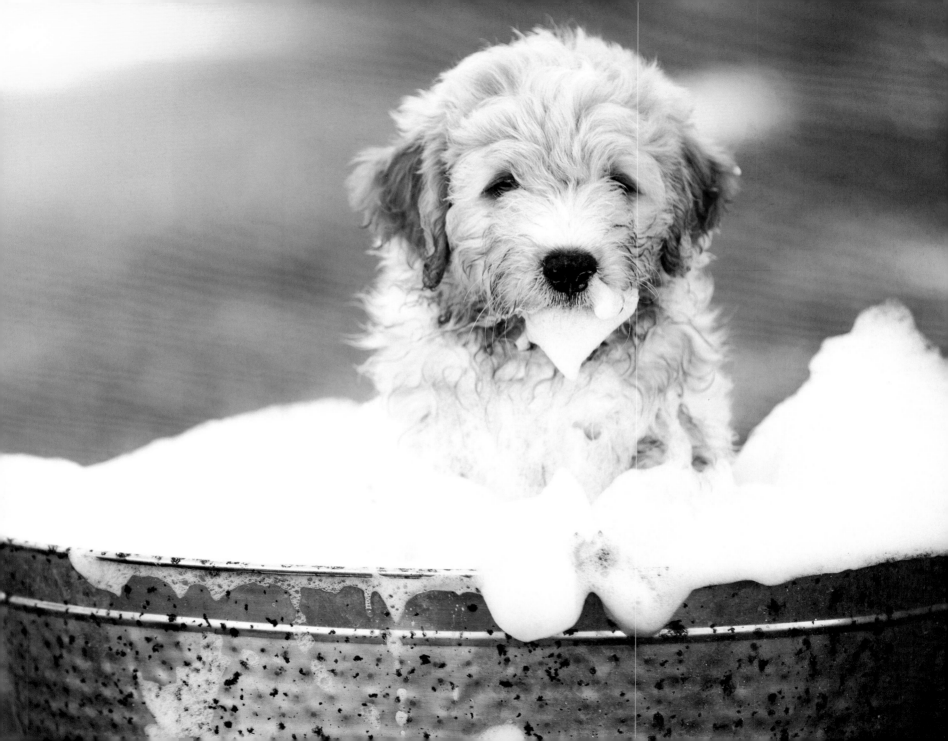

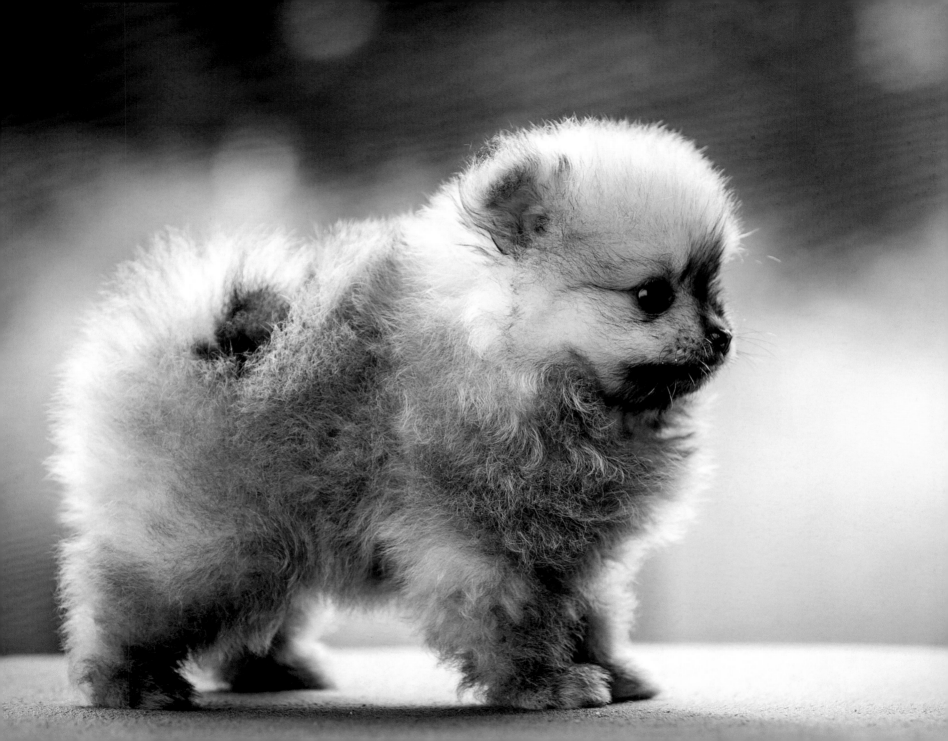

IF I COULD BE HALF THE PERSON MY DOG IS, I'D BE TWICE THE HUMAN I AM.

CHARLES YU

DOGS HAVE GIVEN US THEIR ABSOLUTE ALL.
WE ARE THE CENTER OF THEIR UNIVERSE.
WE ARE THE FOCUS OF
THEIR LOVE AND FAITH AND TRUST.
THEY SERVE US IN RETURN FOR SCRAPS.
IT IS WITHOUT A DOUBT THE BEST
DEAL MAN HAS EVER MADE.

ROGER CARAS

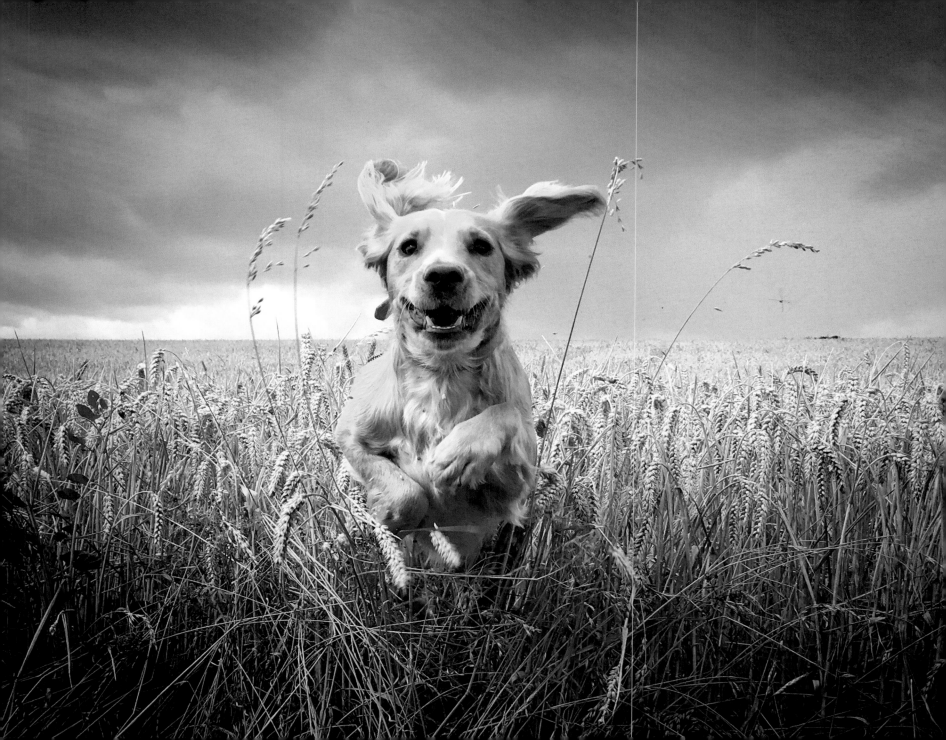

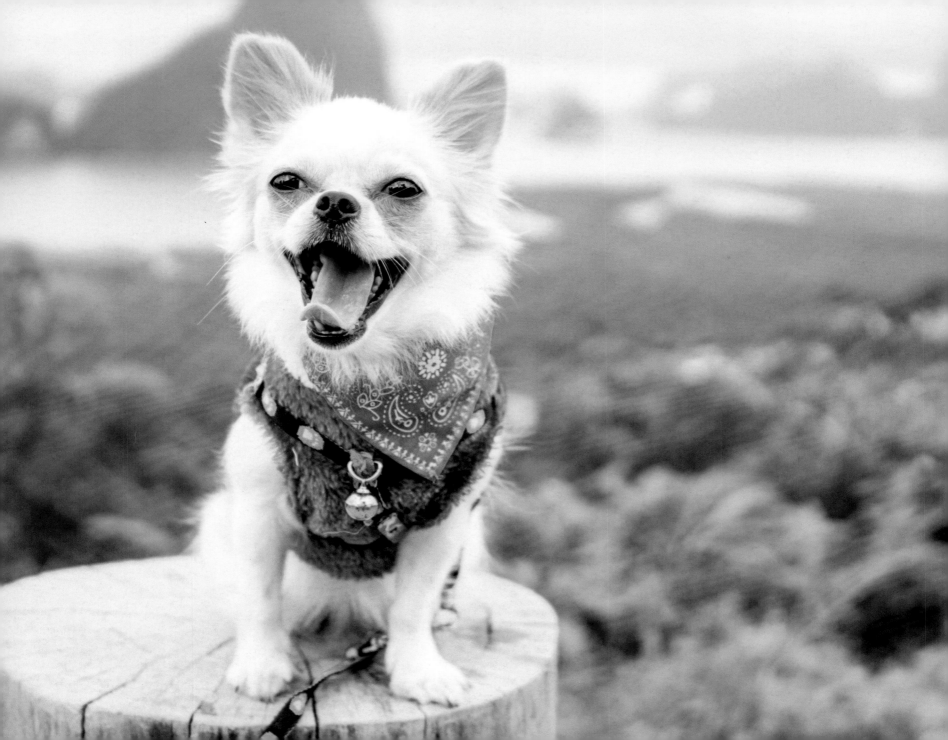

THE DOG LIVES FOR THE DAY, THE HOUR, EVEN THE MOMENT.

ROBERT FALCON SCOTT

WHOEVER SAID
YOU CAN'T BUY HAPPINESS
FORGOT LITTLE PUPPIES.

GENE HILL

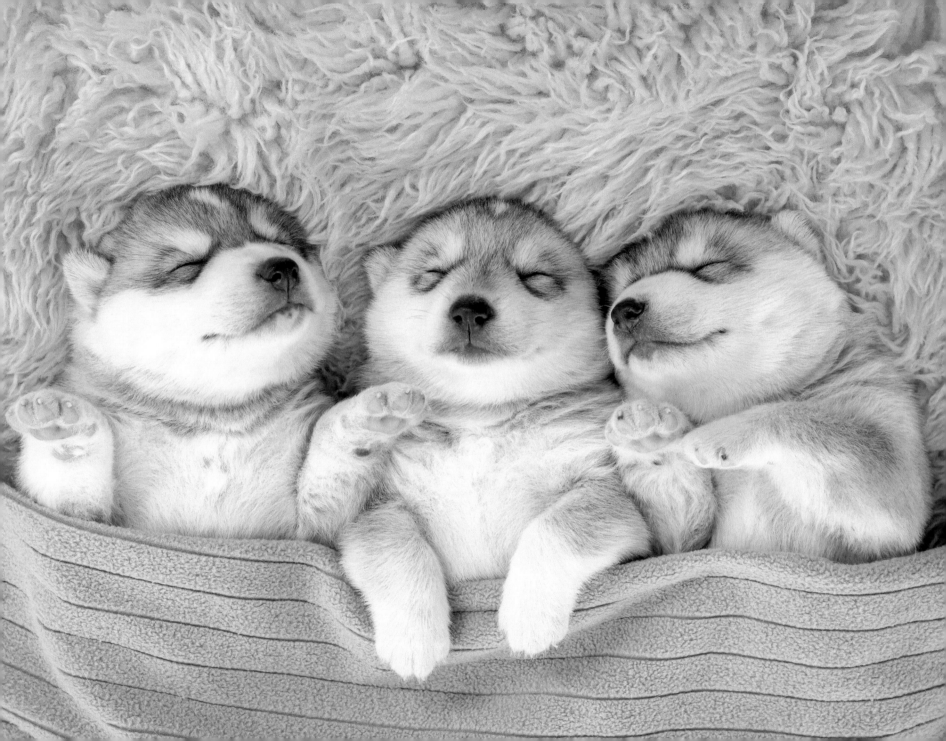

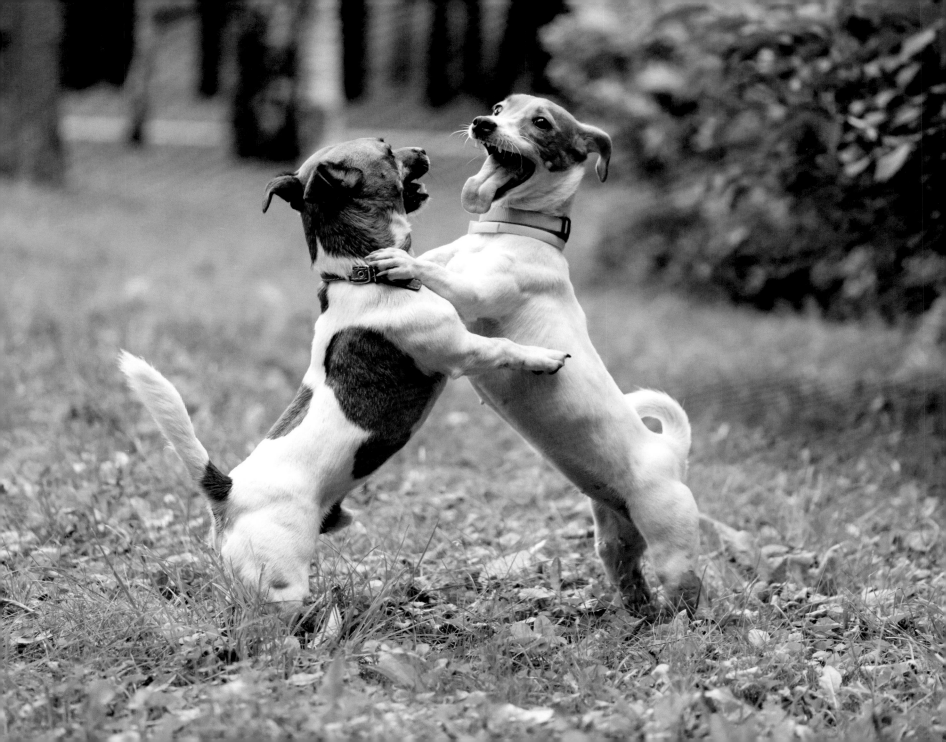

DOGS LAUGH, BUT THEY LAUGH WITH THEIR TAILS.

MAX EASTMAN

IT'S NOT THE SIZE OF THE DOG IN THE FIGHT;

IT'S THE SIZE OF THE FIGHT IN THE DOG.

MARK TWAIN

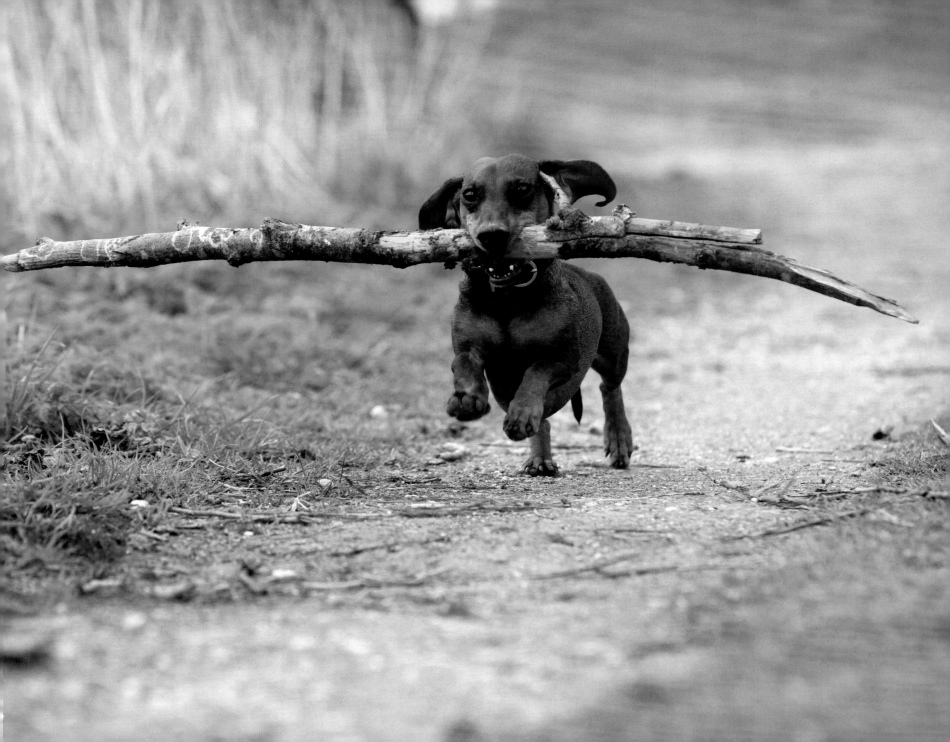

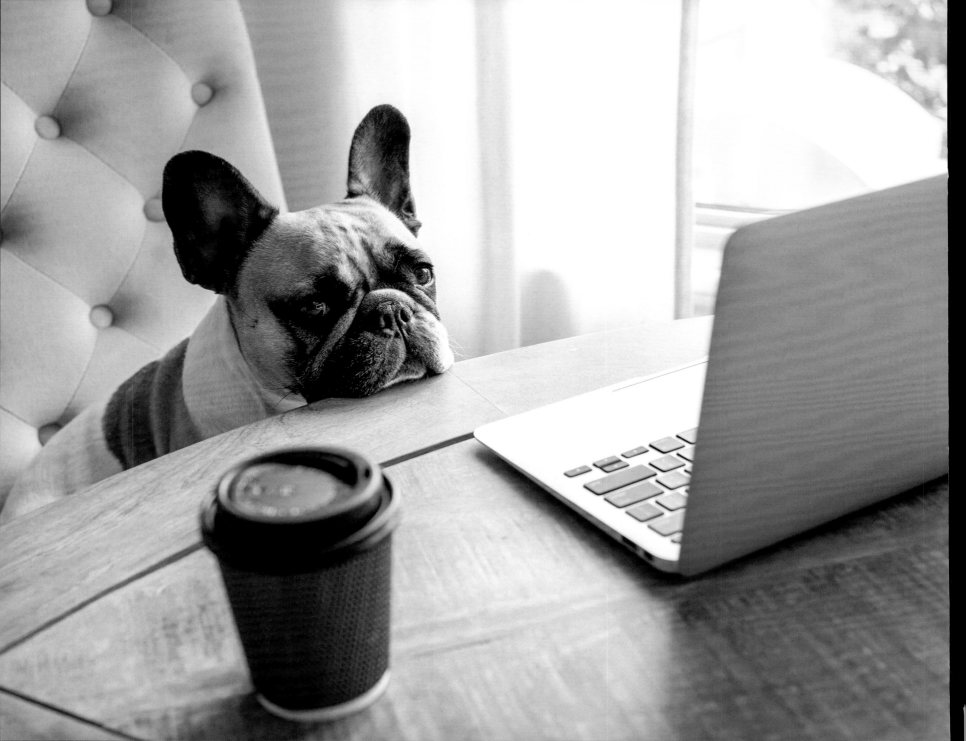

EVERYTHING I KNOW,
I LEARNED FROM DOGS.

NORA ROBERTS

DOGS ARE OFTEN HAPPIER THAN MEN
SIMPLY BECAUSE
THE SIMPLEST THINGS ARE
THE GREATEST THINGS FOR THEM!

MEHMET MURAT ILDAN

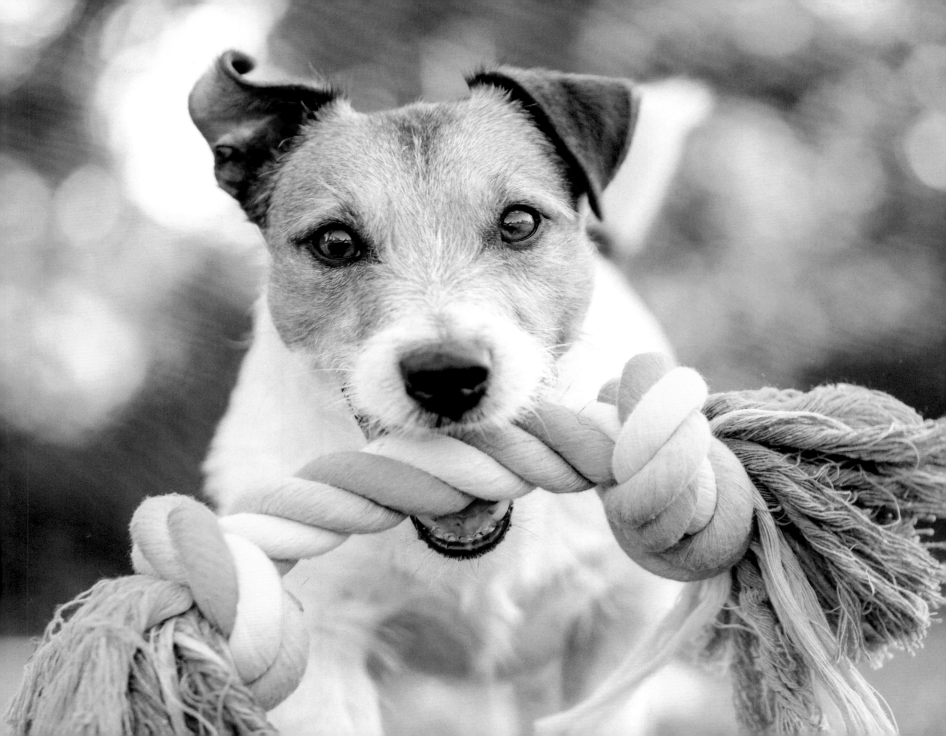

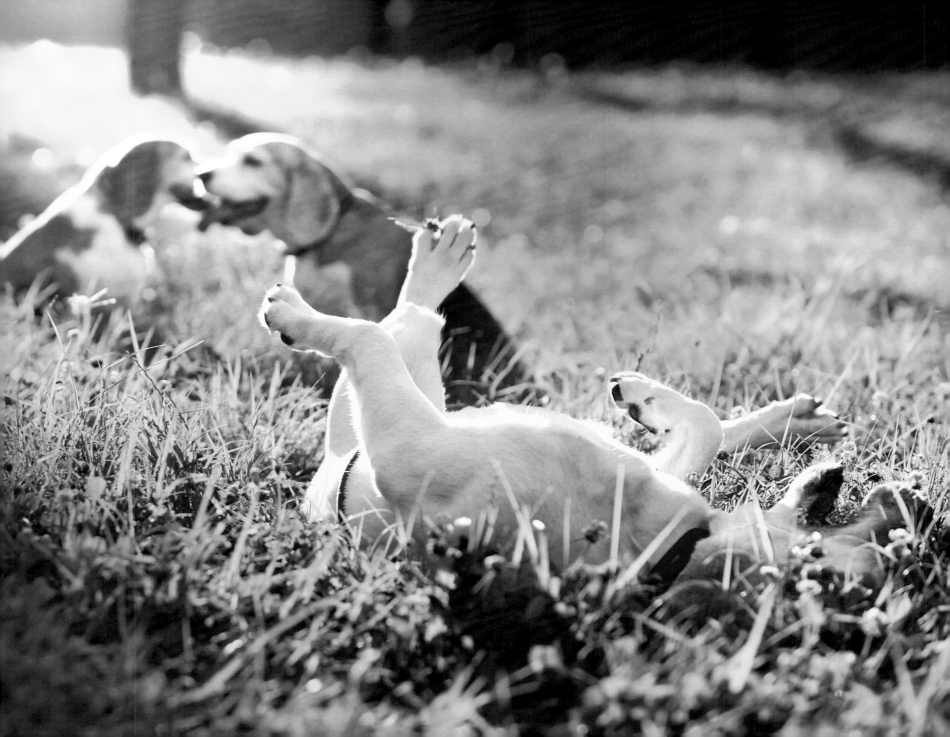

A DOG CAN'T THINK THAT MUCH ABOUT WHAT HE'S DOING, HE JUST DOES WHAT FEELS RIGHT.

BARBARA KINGSOLVER

DOGS ARE NOT OUR WHOLE LIFE, BUT THEY MAKE OUR LIVES WHOLE.

ROGER CARAS

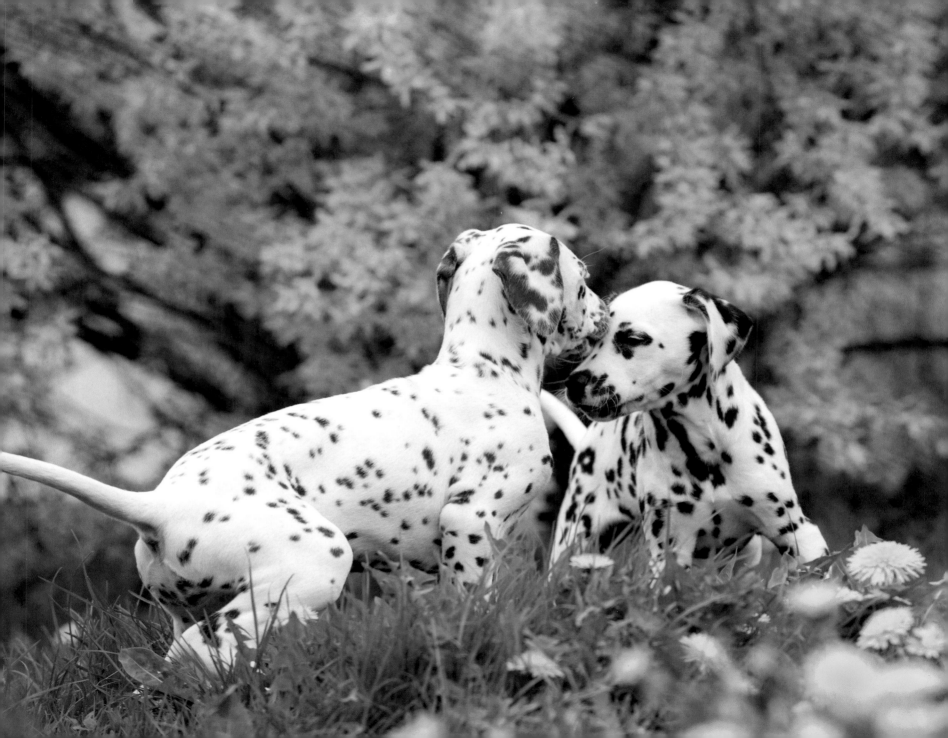

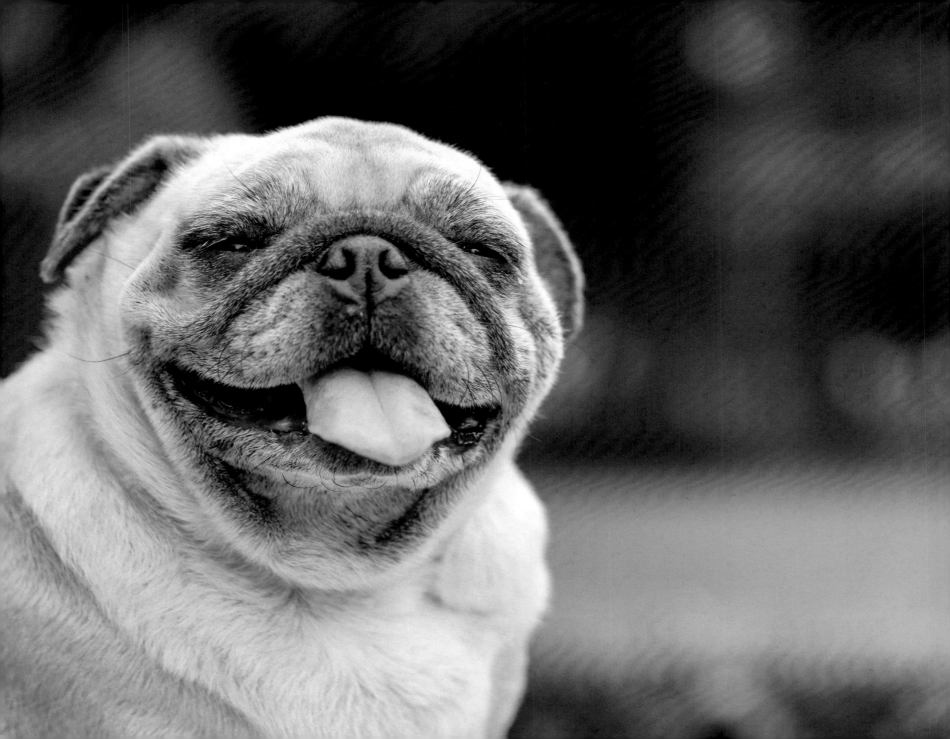

DON'T ACCEPT
YOUR DOG'S ADMIRATION
AS CONCLUSIVE EVIDENCE
THAT YOU ARE WONDERFUL.

ANN LANDERS

THE WORLD WOULD BE A NICER PLACE
IF EVERYONE HAD THE ABILITY TO
LOVE AS UNCONDITIONALLY AS A DOG.

M.K. CLINTON

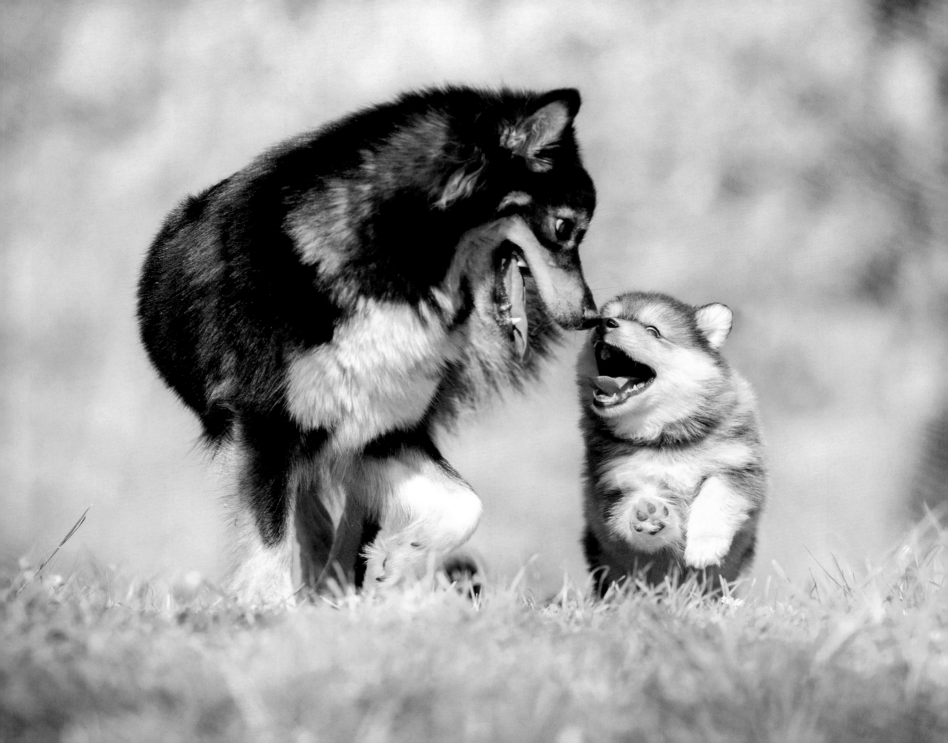

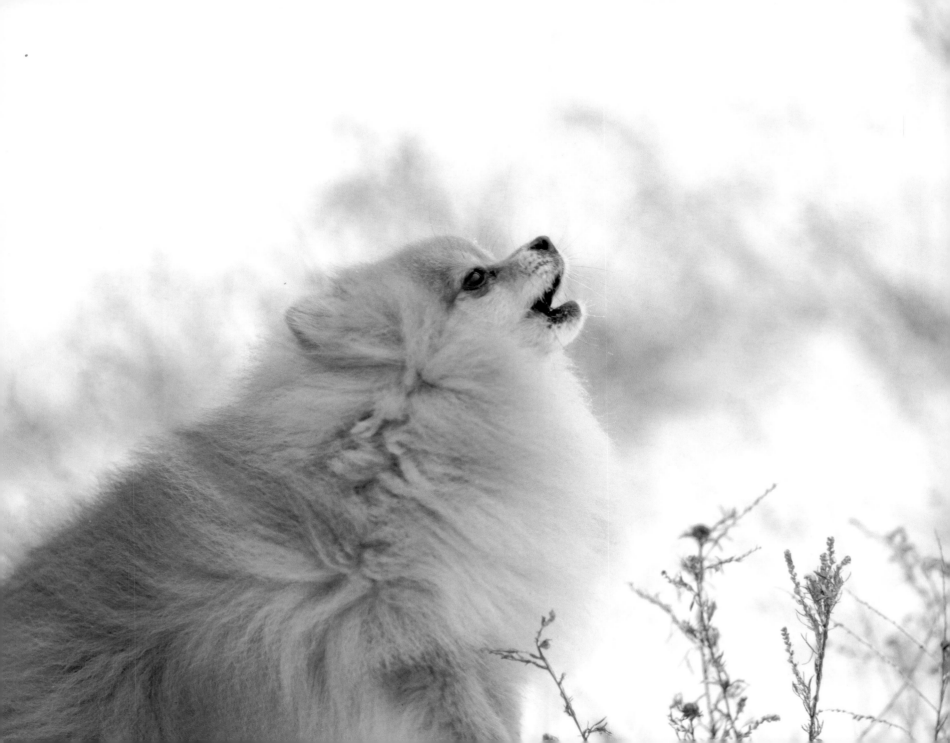

DOGS DO SPEAK,
BUT ONLY TO THOSE
WHO KNOW HOW TO LISTEN.

ORHAN PAMUK

THE BETTER I GET TO KNOW MEN, THE MORE I FIND MYSELF LOVING DOGS.

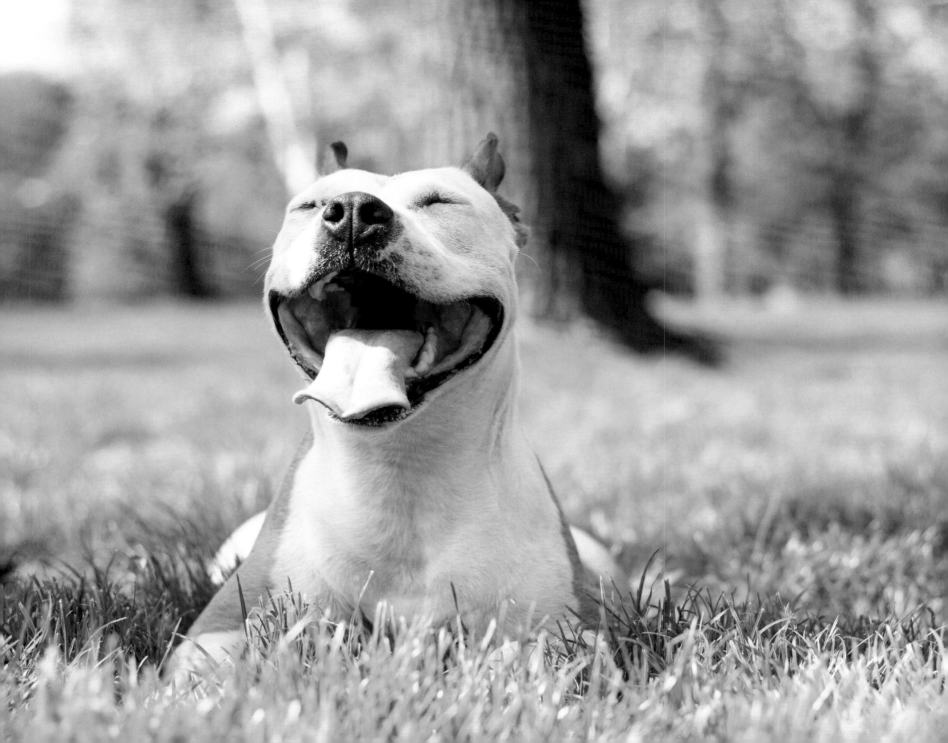

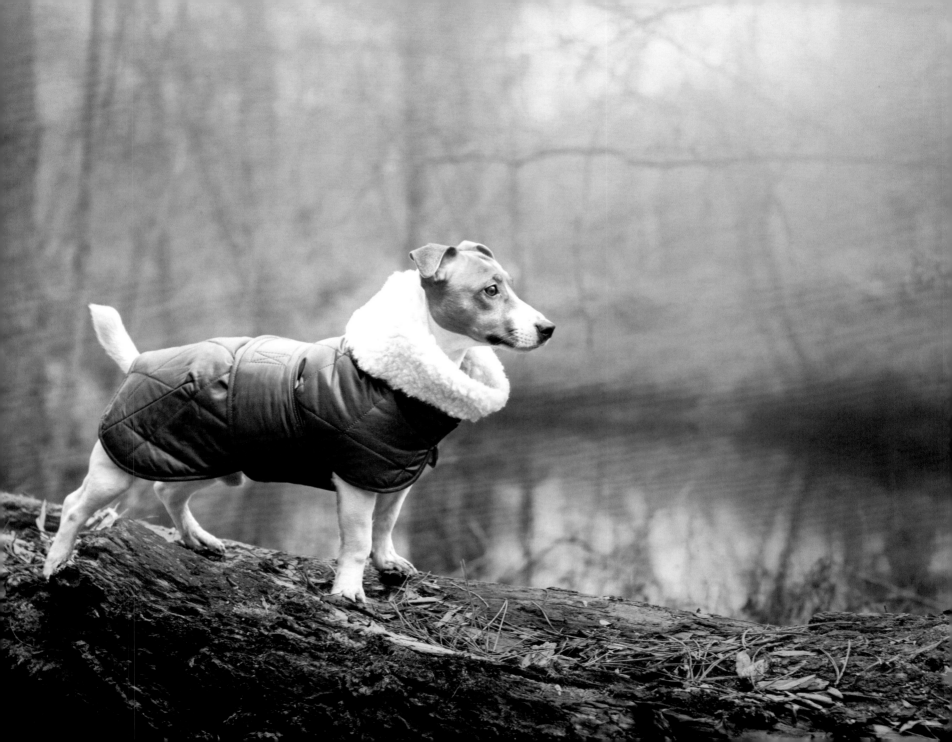

THERE IS ONE OTHER REASON FOR DRESSING WELL, NAMELY THAT DOGS RESPECT IT, AND WILL NOT ATTACK YOU IN GOOD CLOTHES.

RALPH WALDO EMERSON

IN TIMES OF JOY, ALL OF US WISHED WE POSSESSED A TAIL WE COULD WAG.

W.H. AUDEN

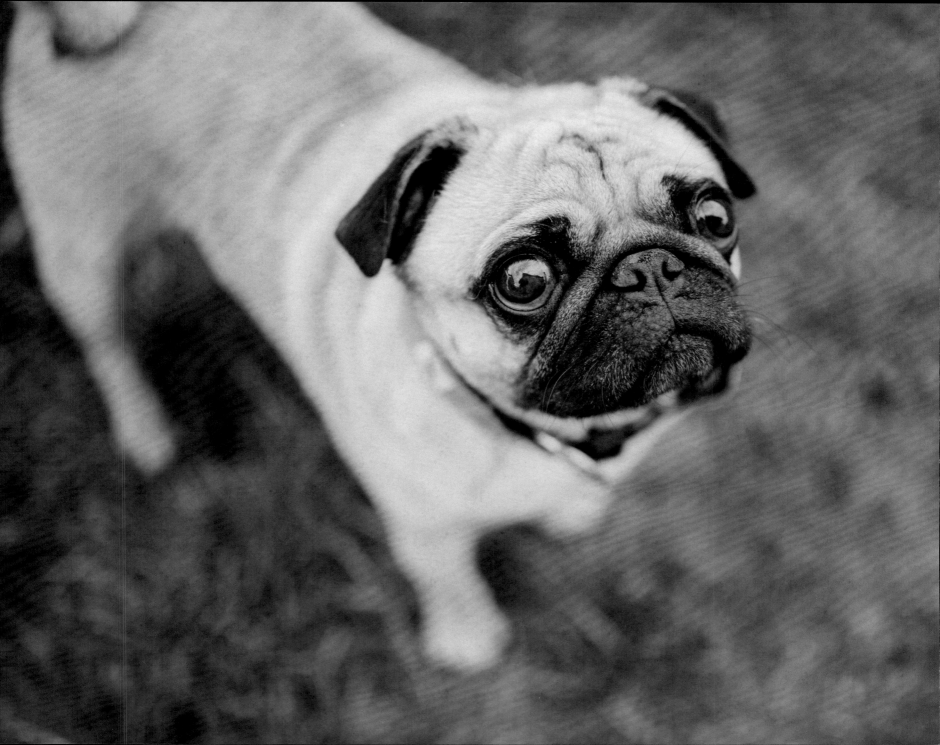

I'VE SEEN A LOOK IN DOGS' EYES,
A QUICKLY VANISHING LOOK
OF AMAZED CONTEMPT, AND
I AM CONVINCED THAT BASICALLY
DOGS THINK HUMANS ARE NUTS.

JOHN STEINBECK

WHAT DO DOGS DO ON THEIR DAY OFF? CAN'T LIE AROUND— THAT'S THEIR JOB!

GEORGE CARLIN

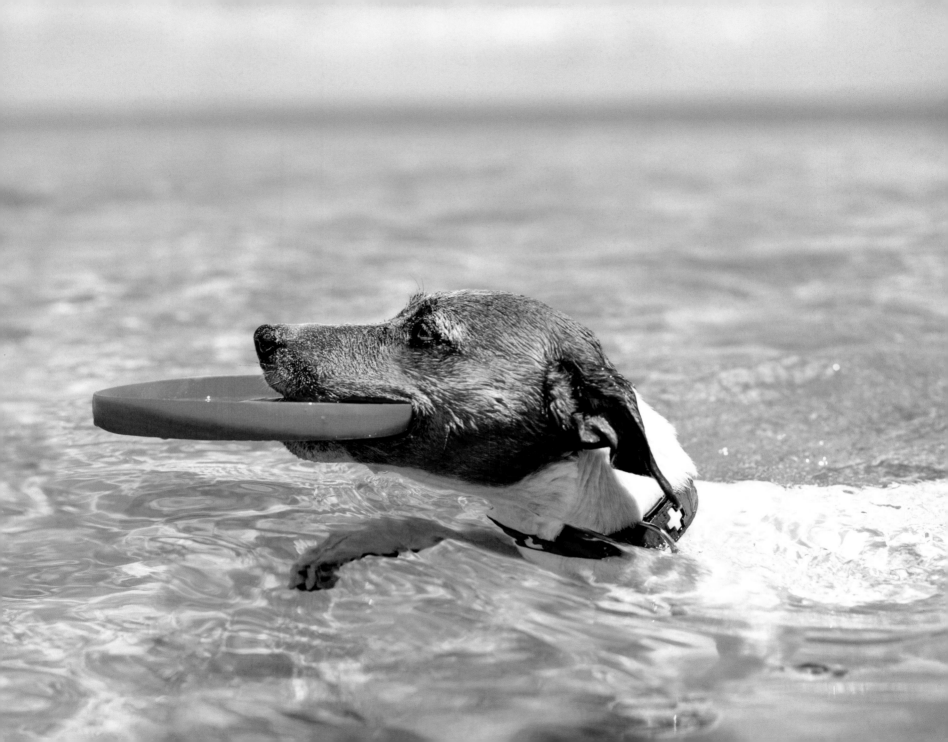

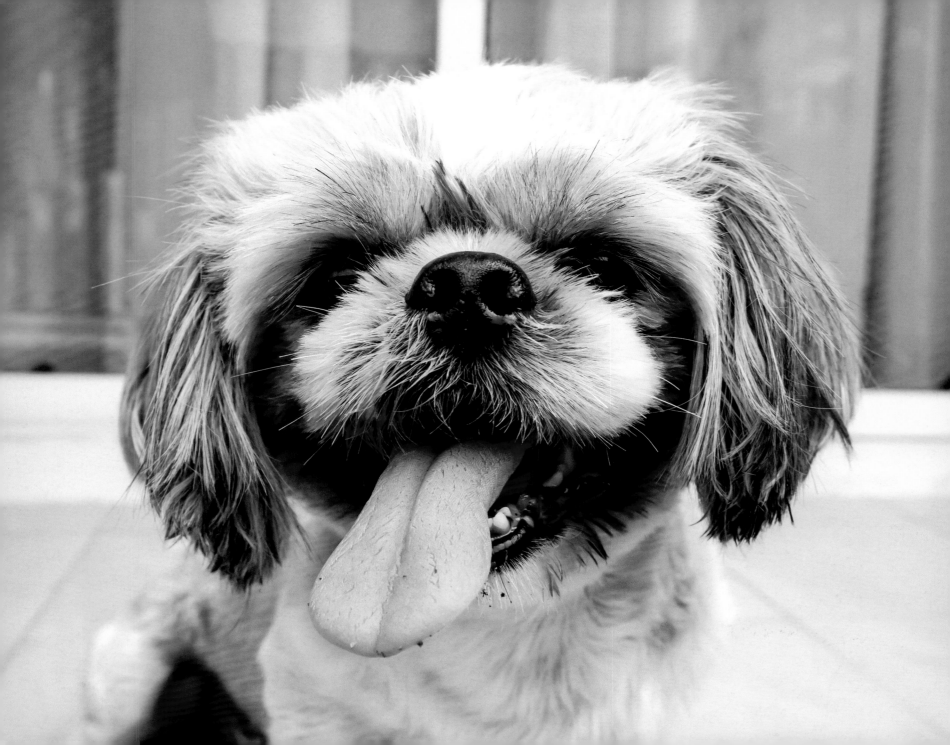

SOMETIMES YOU'RE SURE DOGS HAVE SOME SECRET, SUPERIOR INTELLIGENCE, AND OTHER TIMES YOU KNOW THEY'RE ONLY THEIR SIMPLE, GOOFY SELVES.

DEB CALETTI

A DOG KEEPS HIS LIFE
SIMPLE AND UNADORNED.

BRAD WATSON

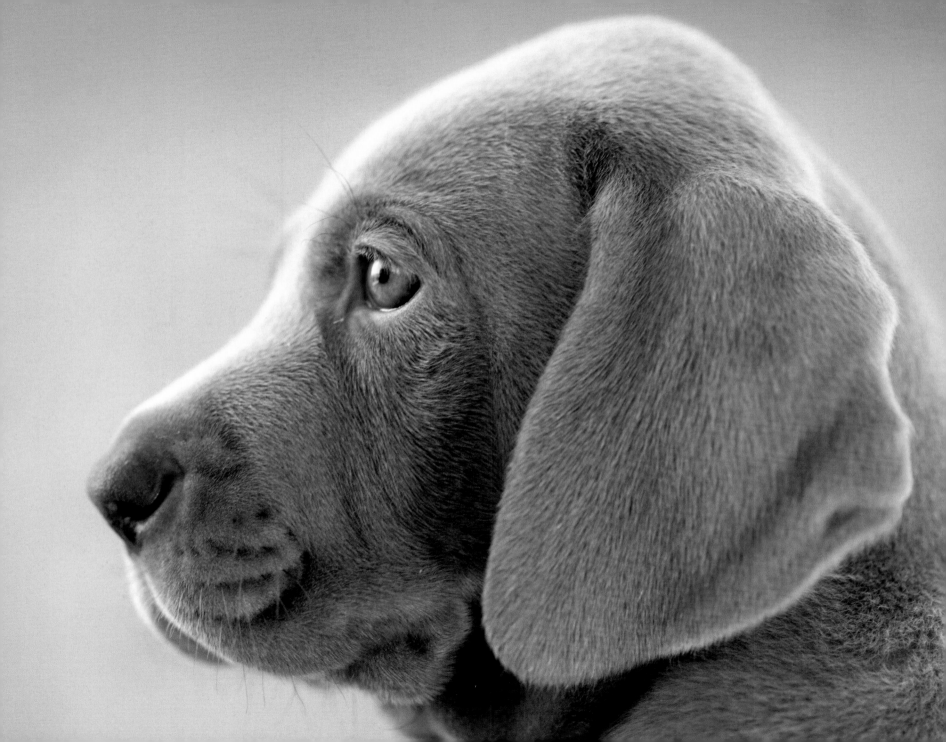

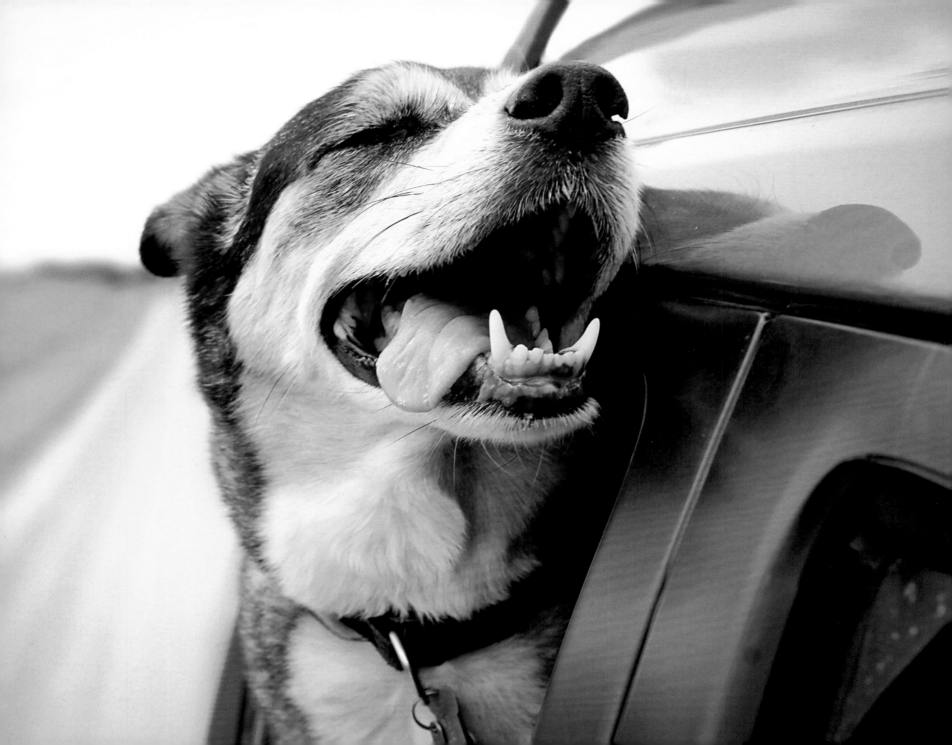

WHY DOES WATCHING A DOG BE A DOG

FILL ONE WITH HAPPINESS?

JONATHAN SAFRAN FOER

A DOG HAS ONE AIM IN LIFE...
TO BESTOW HIS HEART.

J.R. ACKERLEY